P9-DGZ-850

PERIMETER

A CONTEMPORARY PORTRAIT OF LAKE MICHIGAN

KEVIN J. MIYAZAKI

foreword by Mary Louise Schumacher

WISCONSIN HISTORICAL SOCIETY PRESS

Published by the Wisconsin Historical Society Press
Publishers since 1855

Text © 2014 by the State Historical Society of Wisconsin
Photographs © 2014 by Kevin J. Miyazaki

For permission to reuse material from *Perimeter,* ISBN: 978-0-87020-676-4, ebook ISBN: 978-0-87020-677-1, please access www.copyright.com or contact the Copyright Clearance Center, Inc. (CCC), 222 Rosewood Drive, Danvers, MA 01923, 978-750-8400. CCC is a not-for-profit organization that provides licenses and registration for a variety of users.

The *Perimeter* photography project was commissioned by the Haggerty Museum of Art at Marquette University. The project was sponsored in part by the Friends of the Haggerty and the Wisconsin Arts Board, with funds from the State of Wisconsin and the National Endowment for the Arts.

wisconsin**history**.org

Printed in the United States of America
Designed by Percolator

18 17 16 15 14 1 2 3 4 5

Library of Congress Cataloging-in-Publication Data

Miyazaki, Kevin J.
 Perimeter : a contemporary portrait of Lake Michigan / Kevin J. Miyazaki ; foreword by Mary Louise Schumacher.
 pages cm
 ISBN 978-0-87020-676-4 (hardcover : alkaline paper)—ISBN 978-0-87020-677-1 (ebook) 1. Michigan, Lake—Pictorial works. 2. Michigan, Lake, Region—Pictorial works. 3. Michigan, Lake, Region—Social life and customs—Pictorial works. 4. Michigan, Lake, Region—Biography—Pictorial works. I. Title.
 F553.M59 2014
 977.4—dc23 2014018116

♾ The paper used in this publication meets the minimum requirements of the American National Standard for Information Sciences—Permanence of Paper for Printed Library Materials, ANSI Z39.48-1992.

For those who love this lake—past, present, and future

ACKNOWLEDGMENTS

I would like to thank the Haggerty Museum of Art at Marquette University, which initially commissioned the project that came to be known as *Perimeter*. The invitation to think more deeply about the place where I live, and to contribute to the conversation on the importance of freshwater, was a real gift. I'm grateful to the entire museum staff for their support, in particular Director Wally Mason and Curator of Education Lynne Shumow, whose enthusiasm for the project was inspiring.

Thank you to the hundreds of subjects I photographed, most of whom I met only briefly. Your contribution to this project may have only lasted a few minutes, but it had a beautiful, cumulative effect. I'm glad we met and I hope I captured a glimpse of your love for Lake Michigan.

Kate Thompson at the Wisconsin Historical Society Press saw potential for *Perimeter* as a book, and I'm grateful to her and Kathy Borkowski for their vision. And to Laura Kearney, who patiently guided the production of the book you're holding.

I'm grateful for the thoughtful words of Mary Louise Schumacher, whose coverage of the art in our region is more important than ever. And to John Gurda, for allowing me to lift a particularly apt quote from one of his fascinating lectures about the lake.

To those who assisted me at times during the project: Brianna Prudhomme, Jessica Kaminski, Greg Ruffing, Patrick Castro, and Alexa Bradley of On the Commons. During my trip around the lake, I reached out to many people whose advice and insights were invaluable. Thank you to all those who continued to point me in the right direction.

Lastly, thank you to my partner, Marilu Knode, whose support never seems to end.

ABOUT *PERIMETER*

The quality of life and the quality of the water are inseparable.
—John Gurda, historian

I was born in Milwaukee and have lived much of my life just west of the city. Lake Michigan, though only a few miles away, hasn't been a part of my everyday landscape. But like most who live in its proximity, I know the lake is embedded in the cultural fabric of where I choose to live. It's assuringly strong and ever-present. It aids in physical and mental orientation, like a giant, aquatic compass.

When I was approached by the Haggerty Museum of Art at Marquette University in 2012, they were seeking to commission new artwork that related to freshwater and the Great Lakes. Their interest was part of an ongoing and important dialogue happening in the city of Milwaukee—that of freshwater research, which runs deep in the local environmental, business, political, and academic communities.

I chose to examine Lake Michigan, but rather than focusing primarily on the water, I would represent the people most affected by its health. Who were the people living, working, and enjoying the water every day? I aimed to find and photograph them and to create a contemporary portrait of Lake Michigan. To do so, I proposed to drive around the perimeter of the lake, traveling counterclockwise through Wisconsin, Illinois, Indiana, and Michigan. In order to physically see as much of the lake as possible, I would stay off all interstate highways, keeping the water on my left and land on my right. I was, in effect, going to make a giant, beautiful left turn.

For the trip, I created a portable photo studio out of plumbers' PVC pipe, which I could strap to the top of my car and erect quickly to photograph the people I met. There were some specific, compelling subjects I'd identified in advance, but most were

just people I encountered while traveling. I set up on beaches and in parks, on boat docks and in backyards. In all, I photographed nearly three hundred subjects. They were beachgoers, scientists, longshoremen, environmentalists, artists, commmunity leaders, athletes, commercial fishermen, ferry captains, boatbuilders, and surfers.

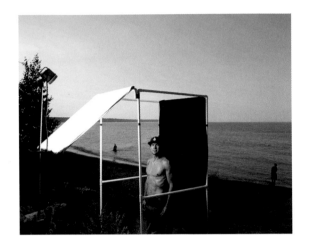

At Montrose Beach Park in Chicago, I photographed a diverse group of city dwellers reveling in the warm, late-day sun. Near Gary, Indiana, I met and photographed proud union steelworkers. In Harbor Springs, Michigan, I sat in a park with Frank Ettawageshik as he sang me the Native American water song. At the end of a long, rural Upper Peninsula road, I photographed Naomi Sanders, an eighty-one-year-old volunteer at the Seul Choix Point Lighthouse. And in Sevastopol, Wisconsin, I met Amy Lukas and Mary Catterlin, who were midway through their own perimeter trip, traveling around the lake in a homemade dugout canoe.

The drive itself was an investigation of access. In 1,800 miles, I found gorgeous, long stretches of road along the lake. But I also found places with no easy access, encumbered by industry or posted private property signs. Some of the most gorgeous spots I found were small, humble public places, like Robert La Salle County Park near Forestville, Wisconsin. To log my journey, I photographed the water as I went, studying the point where the water met the sky, and keeping the center of the lake as my literal and spiritual axis.

I don't claim to be an expert on Lake Michigan, even after this journey. I don't know what the future holds for the lake in terms of new social and environmental challenges. But I do know this: I met real people who love this body of water and I now see the lake more in terms of lives than liquid. The diversity and vibrancy that I found when photographing the water reflects what I found when I pointed my camera toward land—at the people living, playing, and working on its shores. And that gives me hope.

—KEVIN J. MIYAZAKI

FOREWORD

No landscape has brought a sense of the sublime into ordinary existence quite like the capricious beauty of Lake Michigan, at least in my experience. I grew up beside the Pacific Ocean and spent years living near the Atlantic, too, and I know something of that inexplicable need to be near liquidy expanses.

But just consider the curvaceous plumes of misty white that rise from the surface of the lake in fall, when cold winds sweep over the water still holding onto some of its summer warmth. I've never seen anything quite like those gorgeous, twisting tufts of evaporation that seem to stand at poised attention. The lake looks as if it is being inhaled into the sky.

The drama is of course an ancient one. Sculpted over millennia by advancing and retreating glaciers, the Great Lakes constitute the largest surface freshwater system on Earth, a single, huge, lumbering river flowing east, from lake to lake, gathering in the Saint Lawrence River and spilling out into the Atlantic.

Seen on an atlas, as if from high above Earth's surface, the Great Lakes resemble expressive daubs of paint, with curved shapes and soft edges. Among them, Lake Michigan has a particular elegance, falling downward into a pretty lobe. Its lines are supple, especially as it rounds the southern end at Chicago and bends toward South Haven and up to Pentwater on the Michigan side.

Off the map's page, though, the physical reality of the modern shoreline, with its high-end developments, factories, rail yards, roadways, parks, tourist attractions, and

sewage treatment plants, is far from a tidy line. The 1,600-mile perimeter is a seam, at times distinct and at times nearly imperceptible, between water and the kinds of human activities that gather to it today.

Looking at this dark beauty, you'd not know it's sunk into the center of some of the more daunting political and environmental questions of our time. Called the oil of the twenty-first century by some, freshwater is a scarce and contested resource worldwide. Scientists, academics, and leaders from water-related industries have gathered around this timeless place to investigate these contemporary problems, to research invasive species, emerging contaminants, changing ecosystems, sustainable technologies, and the effects of climate change.

This is the context in which Kevin J. Miyazaki, a Milwaukee artist I've known for about a dozen years now, was invited to do his own expedition. The result is a wonderfully perceptive interrogation of landscape, portraiture, cartography, and place called *Perimeter*.

Miyazaki is one of the more thoughtful and rigorous artists I know. He is quite influential, if quietly so, always fostering dialogue and community in some way. He is at the center of an informal circle of photographers, many of whom have been turning toward knowing explorations of place in the region in recent years.

He has an uncanny ability to bring the people in front of his camera to a natural state. You can almost feel the resting heart rate of his subjects who look back at us with a certain directness. It's a quality that orients many of his projects.

Miyazaki traveled the perimeter of Lake Michigan with a portable studio. Setting out alone and sticking mostly to small state highways and country roads, he invited people he met along the way to be photographed.

By setting his subjects outdoors against an all-black background, Miyazaki isolates the scientists, artists, fishermen, ferry captains, boatbuilders, environmentalists, swimmers, and surfers in his portraits from the thing that defines them as a group: the water's edge. As a result, our attention is drawn to these individuals in a very candid way, with a kind of midwestern straightforwardness.

We see the stern and muscular face of a swimmer, standing wet in her bathing suit, her purple goggles slung around her neck; a surfer gripping his battered board; a tattooed gentleman showing off his catch; and two girls serving up a platter of freshly cooked fish.

When these portraits are gathered together, as they are in this book, they coalesce into something more. We discover a community of midwesterners who have an intimate relationship with the water, who study, celebrate, or earn their sustenance from

it, much as people have done in one way or another for hundreds of years. These are not people who care about the lake only in theory or who merely admire its views. These are folks who get wet most days.

Miyazaki also took photographs of the lake as he made his way around it. A perfect split of water and sky, these images collectively serve as a portrait of the lake itself and its dynamic, mutable appearance. In these waterscapes we see a brilliant, turquoise chop set beneath a baby-blue haze or a smooth, violet expanse that bleeds imperceptibly into a pinkish evening sky.

I first encountered *Perimeter* at the Haggerty Museum of Art at Marquette University, which commissioned Miyazaki's project. The portraits and waterscapes were exhibited in separate grids on long, facing walls.

Confronted by a wall of water and sky, I was reminded of the magnitude of time and space and our fundamental smallness. Looking at the faces that Miyazaki had gathered—people with their paddles, fishing rods, and bright yellow slickers—I was awed by the thought that our existence is a matter of shifting molecules, that we're made up of the same stuff as water and sand.

—MARY LOUISE SCHUMACHER
art and architecture critic, *Milwaukee Journal Sentinel*

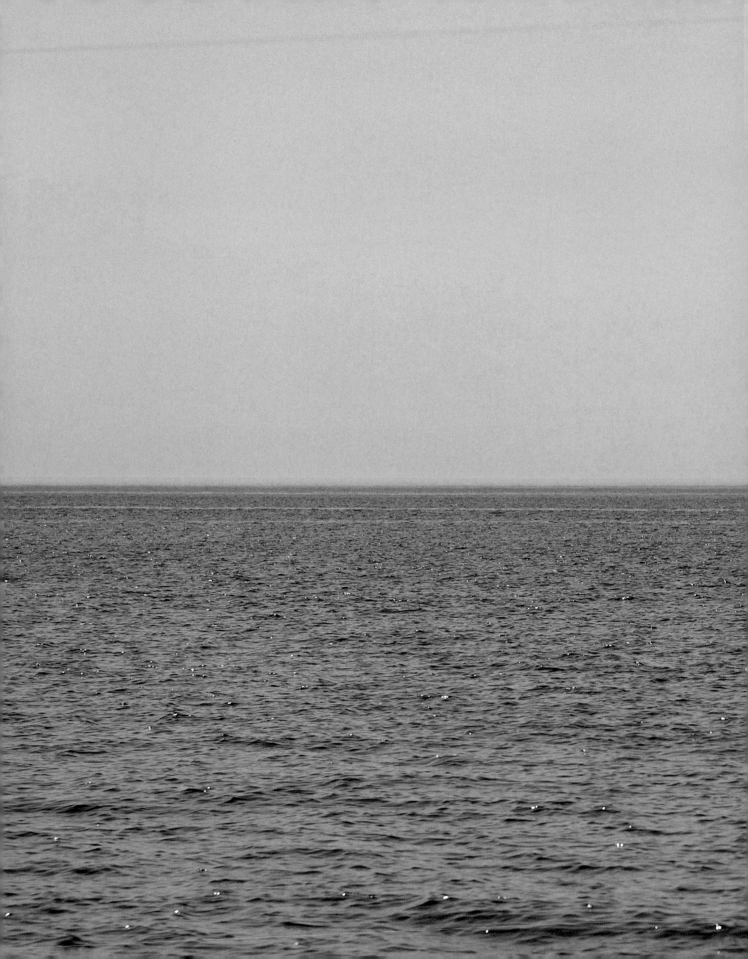

I am magnetically drawn to that place where water meets the sand. There's something about that edge; I feel as if I've "clicked in" when I walk it. It is along the shores of Lake Michigan that I return to center myself, to contemplate life, to think the long, unbroken thoughts that modern life interrupts.

—Loreen Niewenhuis, who hiked the entire perimeter of Lake Michigan and wrote *A 1000-Mile Walk on the Beach*, Saugatuck, Michigan

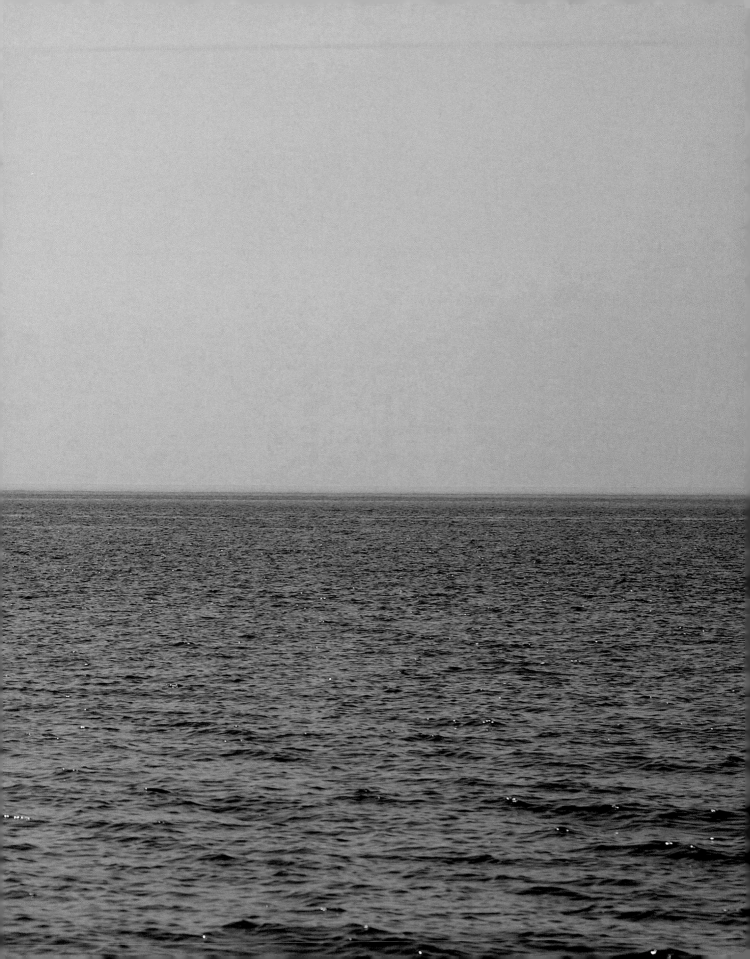

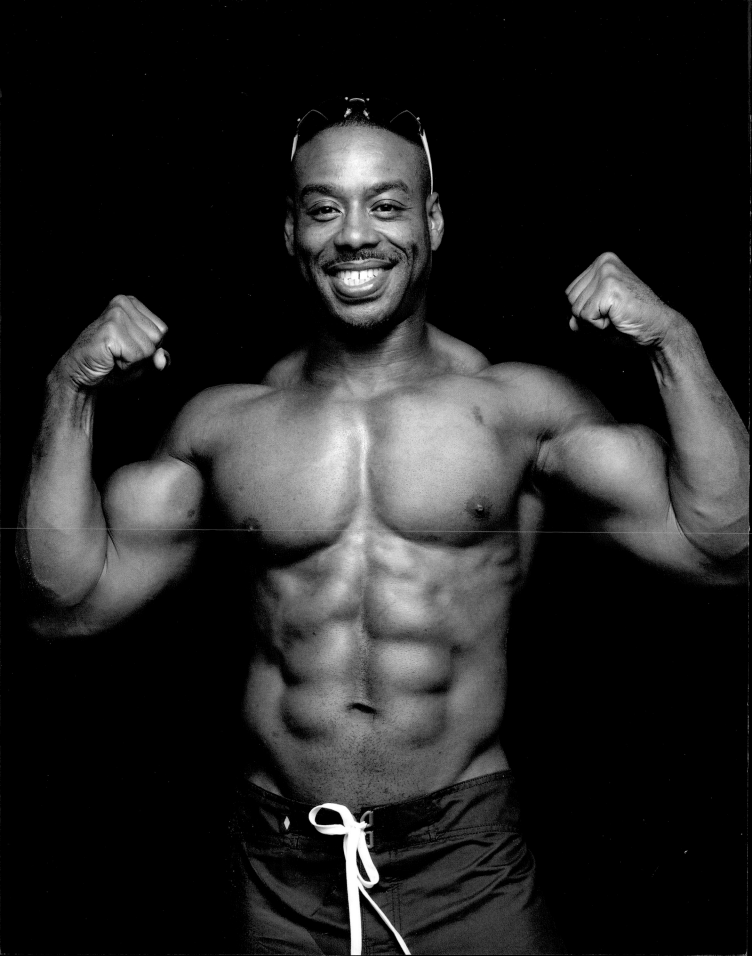

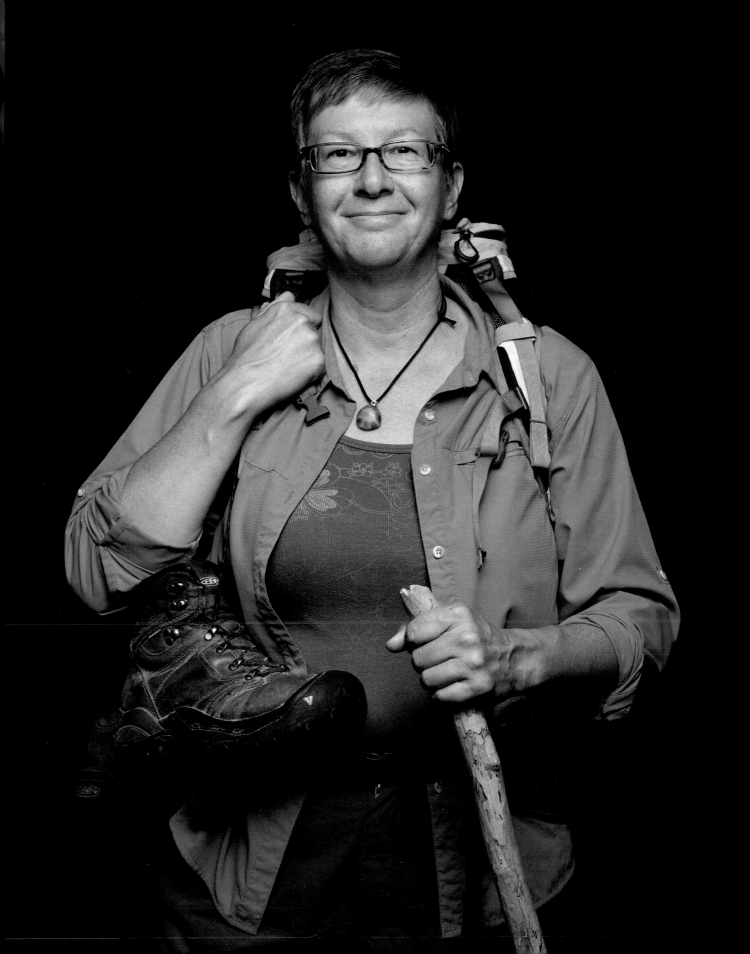

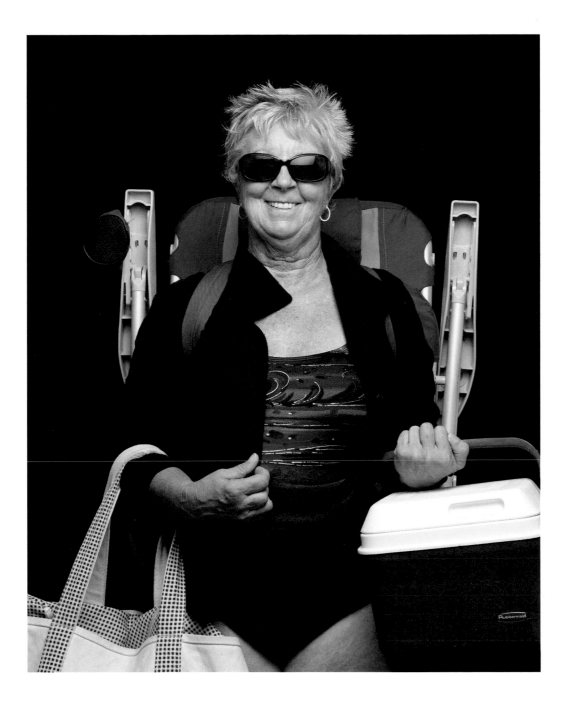

Lionel Connolly (opposite) and Beth Immink (above), visitors to Holland State Park, Holland, Michigan

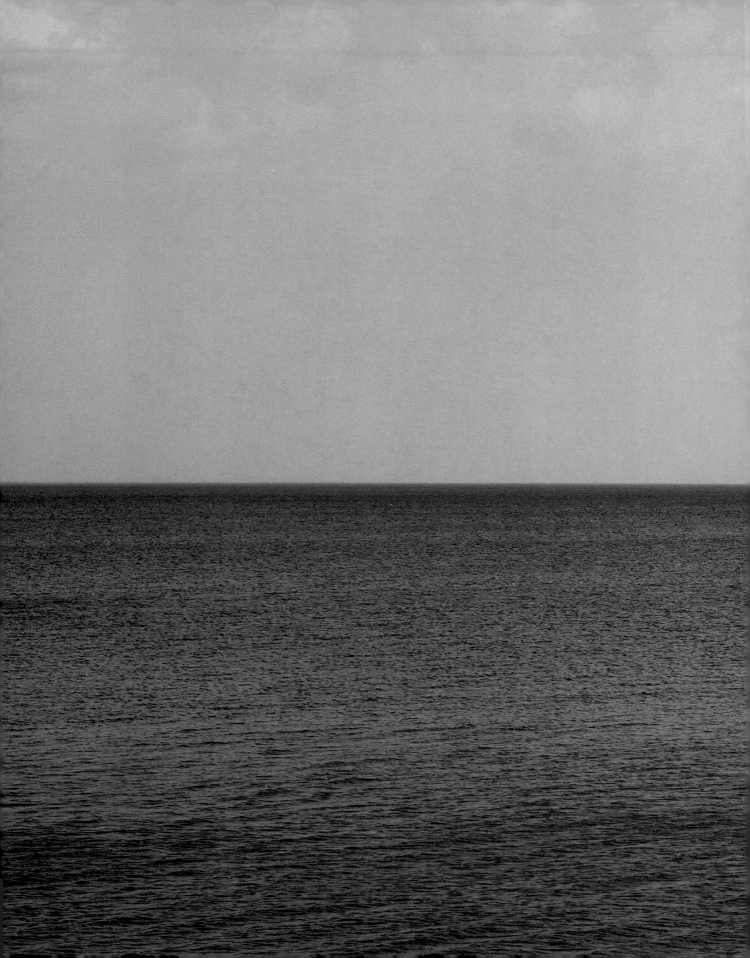

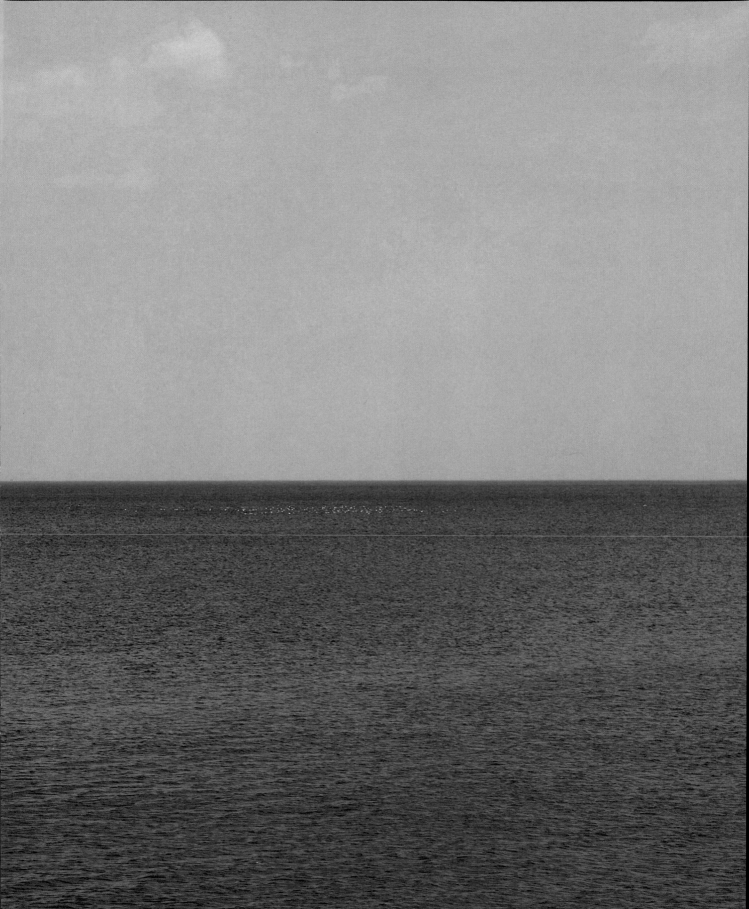

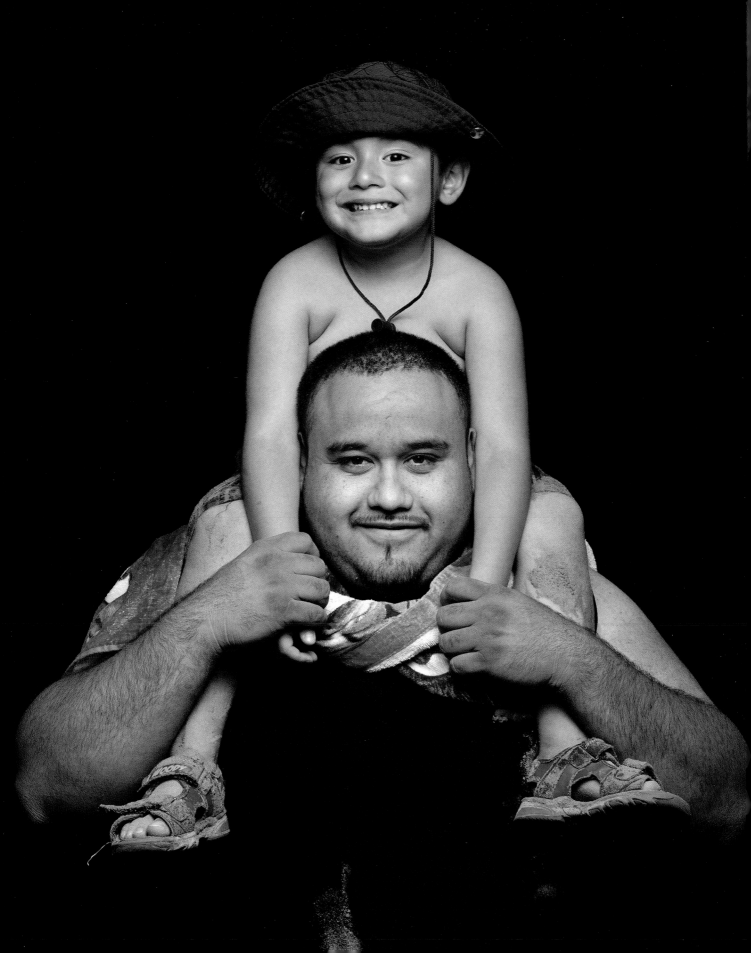

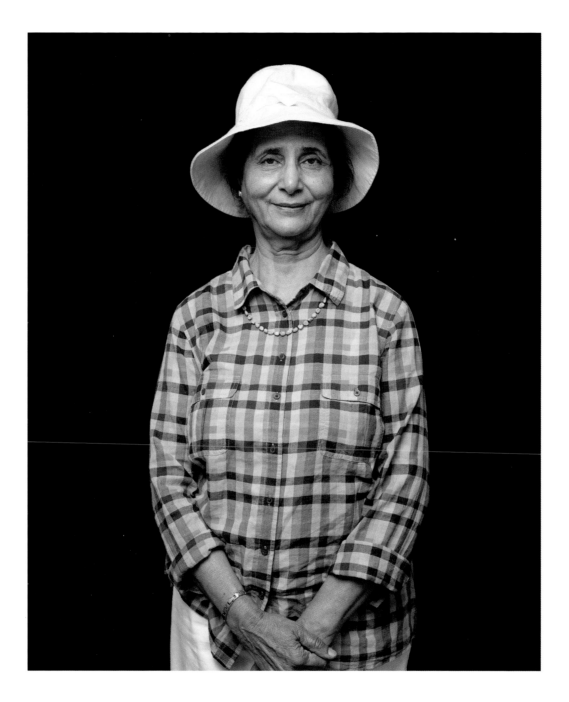

Jorge and Ulysses Moreno (opposite), visitors to Montrose Beach Park, Chicago, Illinois

Mumtaz Shafaat (above), visitor to McKinley Marina, Milwaukee, Wisconsin

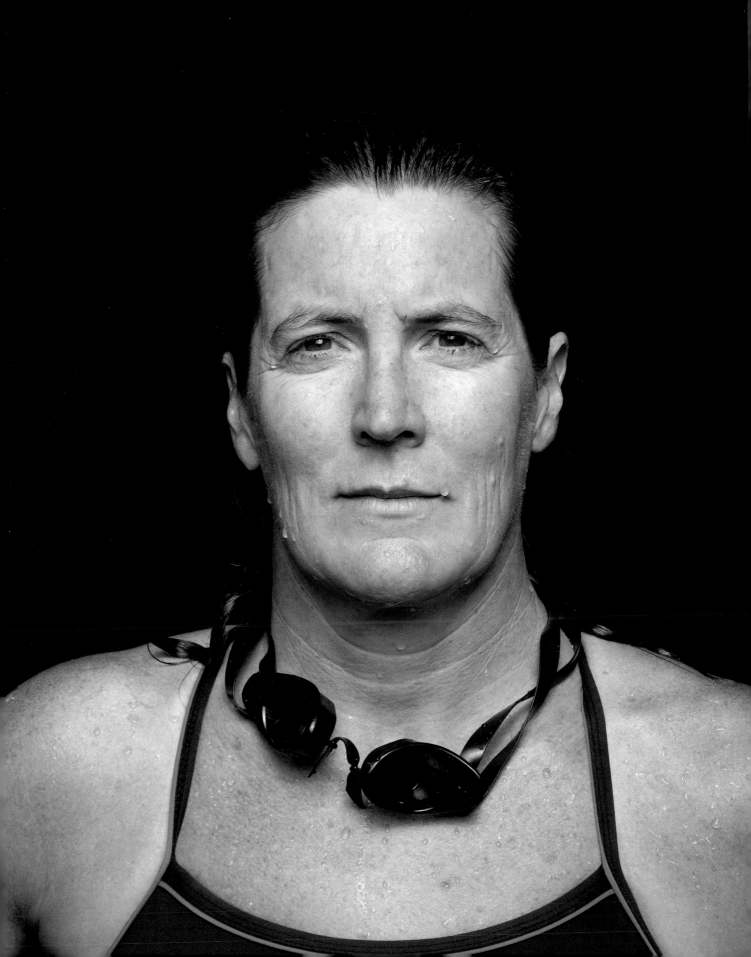

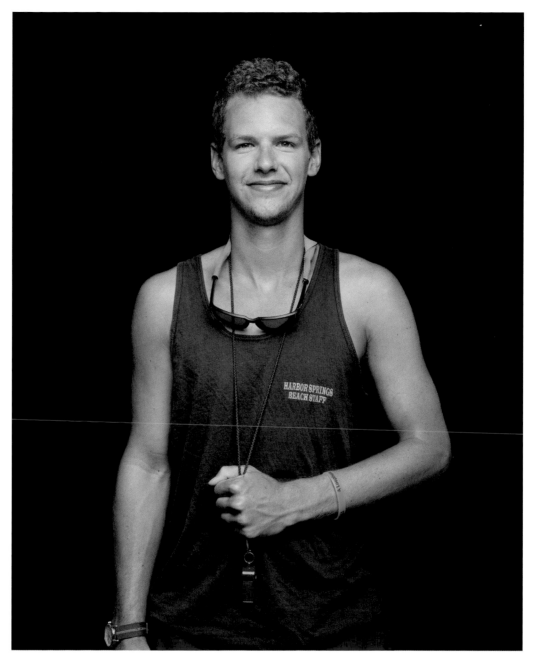

What draws me to Lake Michigan is my history with it. I grew up on it, I fished with my dad, I learned to swim, I faced my fears, I got arrested, I have had summer employment for nine years all because of Lake Michigan. —Erik Krieger, lifeguard, Harbor Springs, Michigan

Marilyn Early (opposite), competitive swimmer and aquatics organizer, Harbor Springs, Michigan

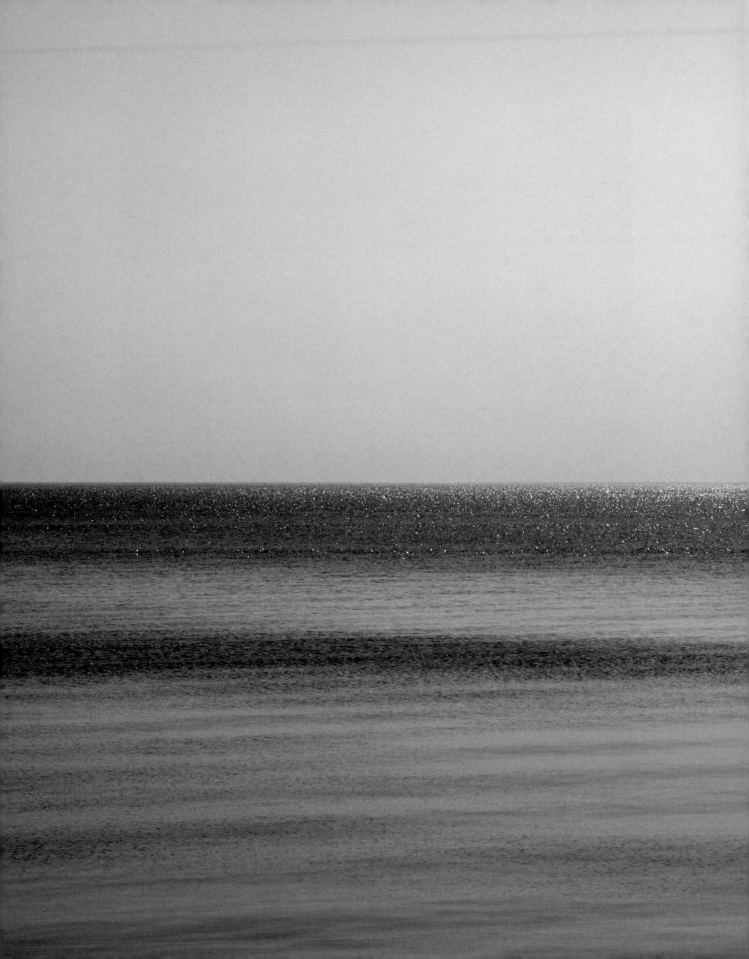

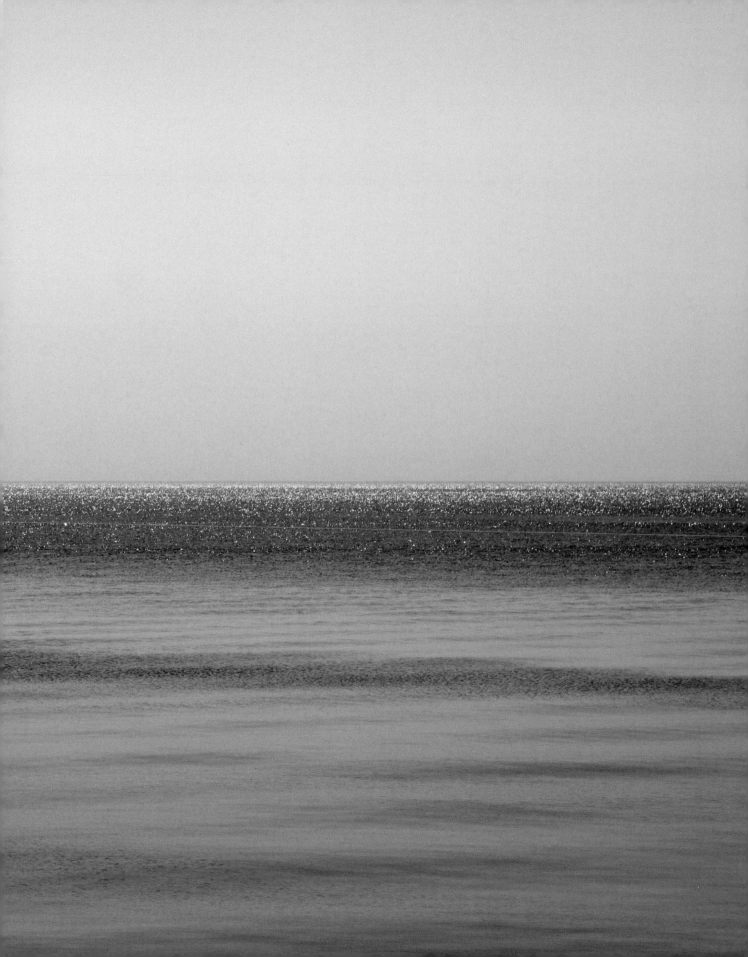

I am a fifth-generation commercial fisherman just like my father and grandfathers before me. I was born to catch fish—it is in my blood. I've never done anything else and don't care to.

—Ben Peterson, Native American trap fisherman, Fairport, Michigan

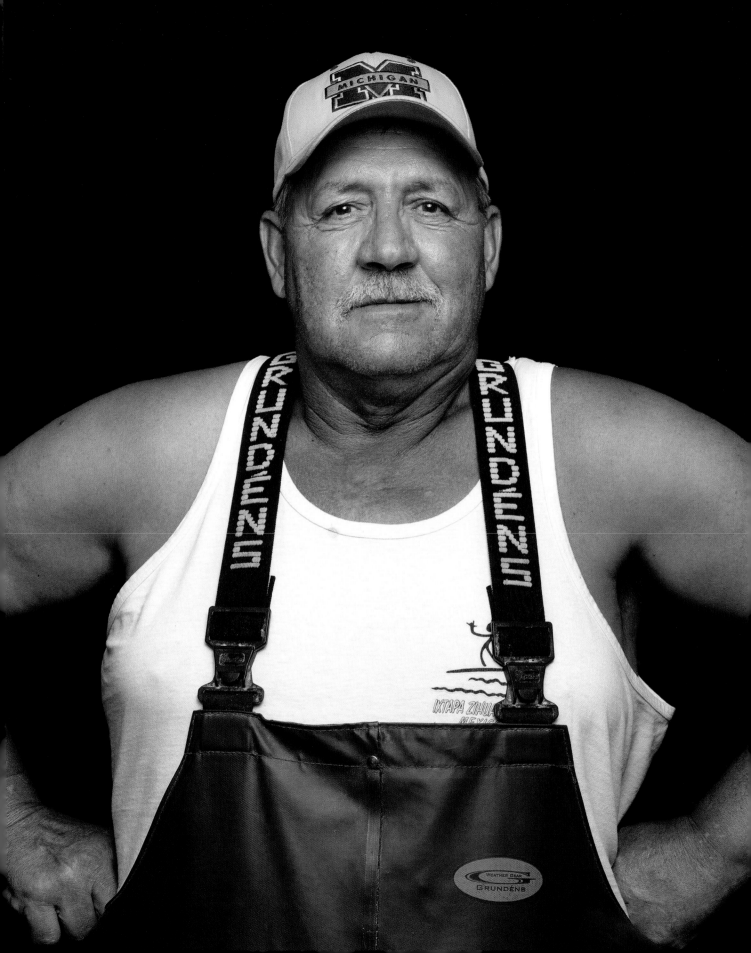

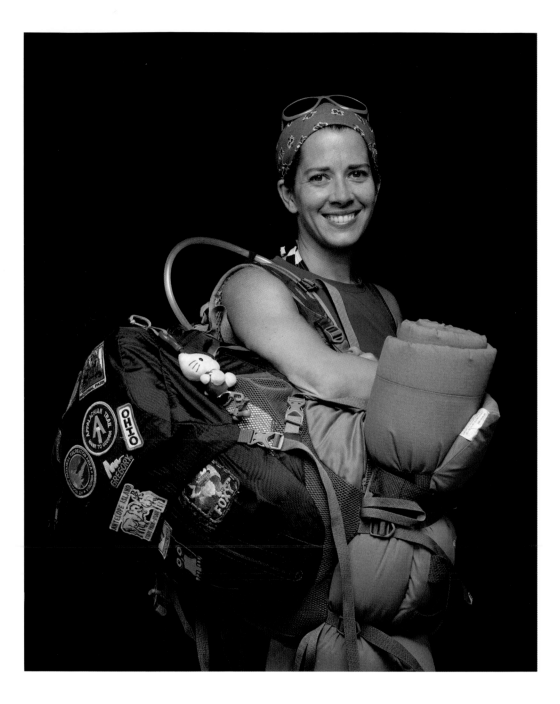

Backpackers heading to North Manitou Island from Fishtown, Leland, Michigan: Robyn Huth (above) and (opposite, clockwise from top left) Jeremy Taylor, Lindsay Taylor, Charles Hall, Helena Hall

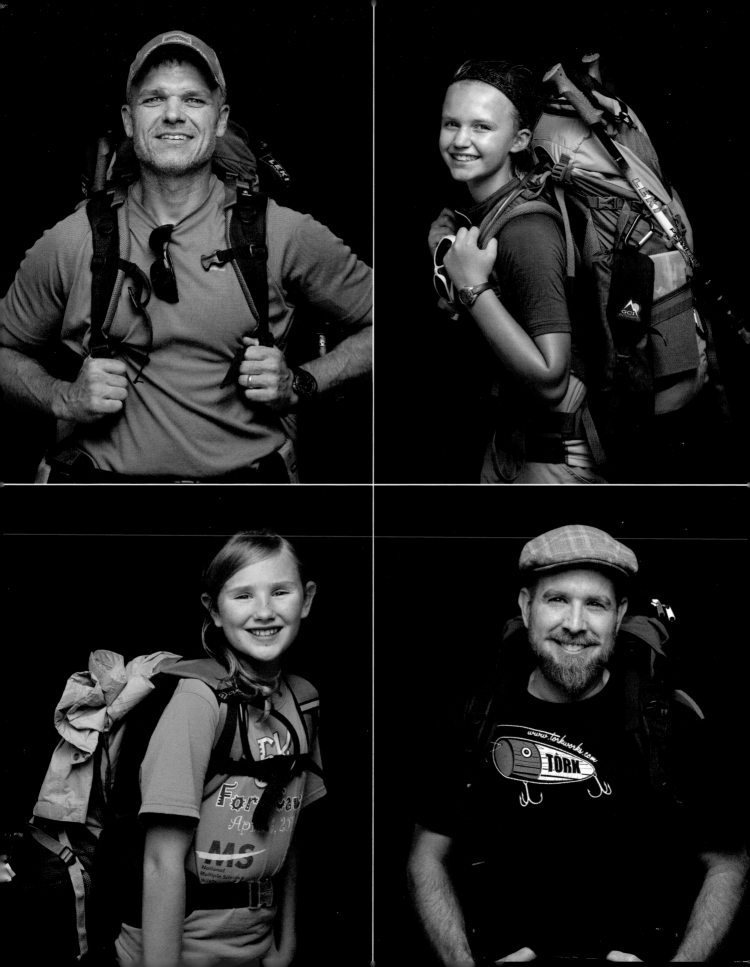

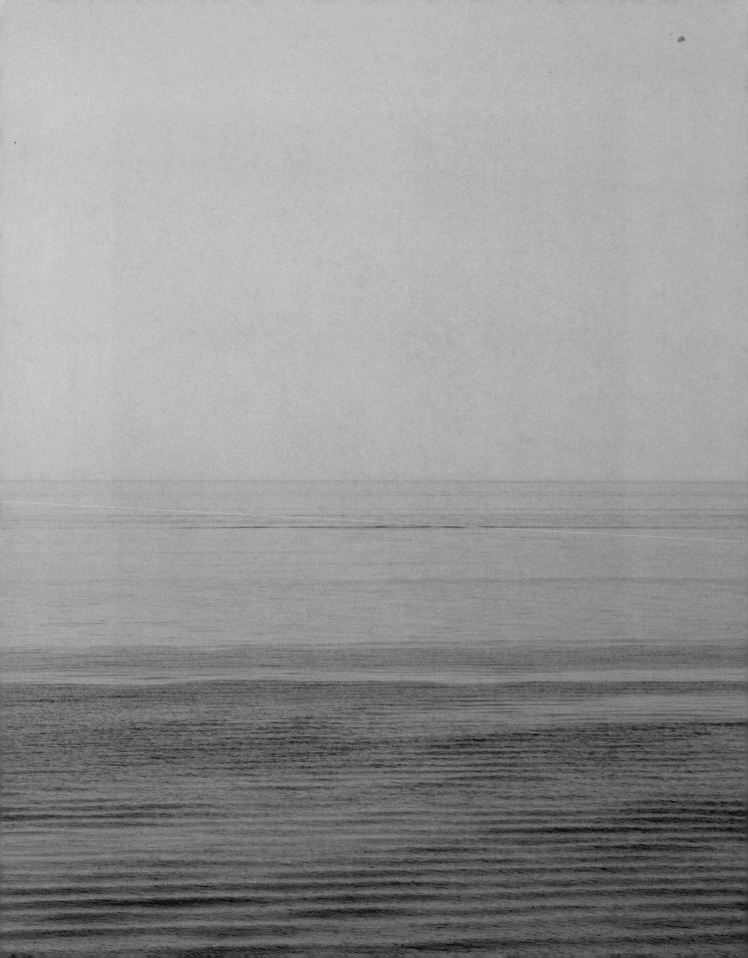

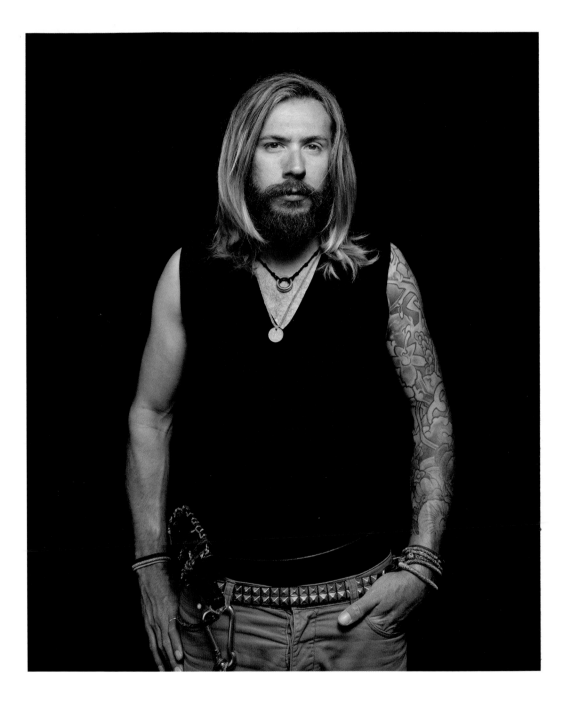

Owen Stefaniak (above), crew member of the schooner *Madeline*, Port Washington, Wisconsin

Carlos Canario (opposite), captain of the schooner *Denis Sullivan*, Port Washington, Wisconsin

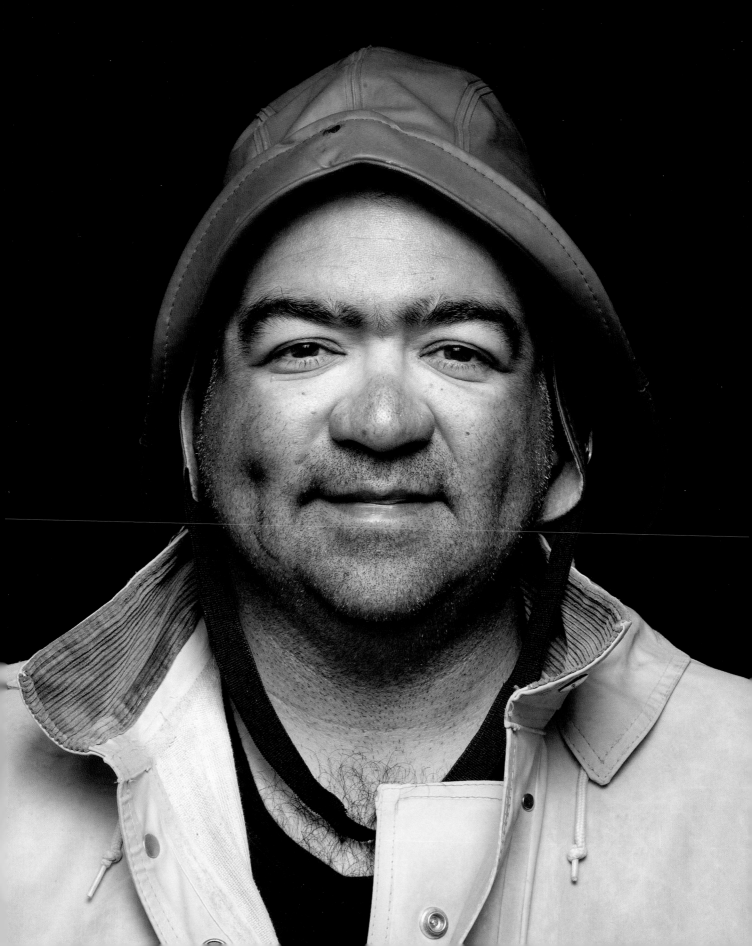

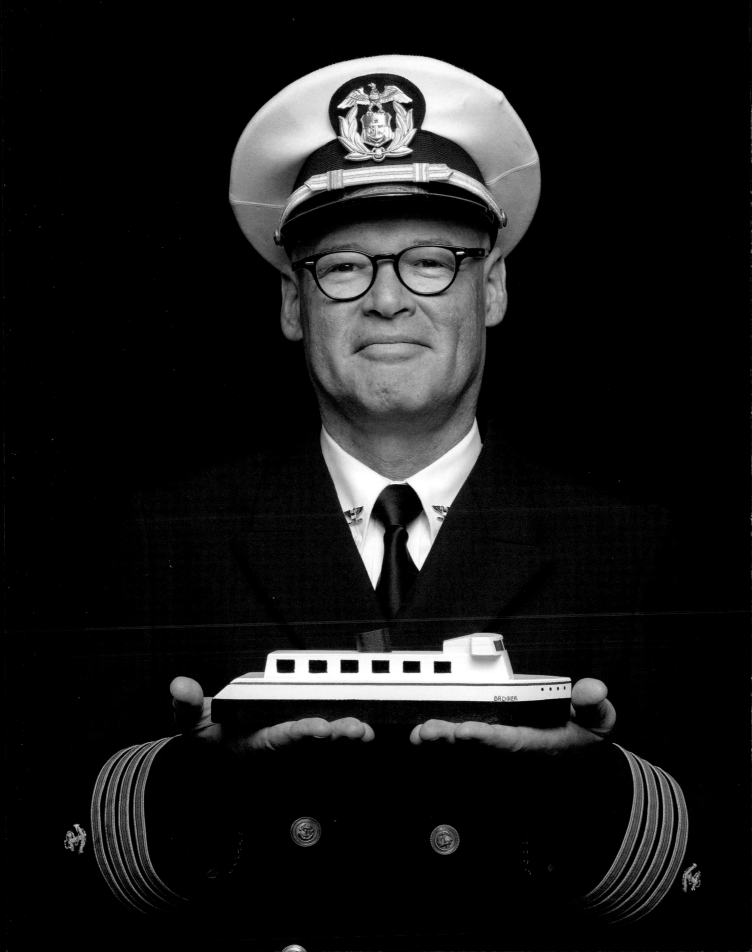

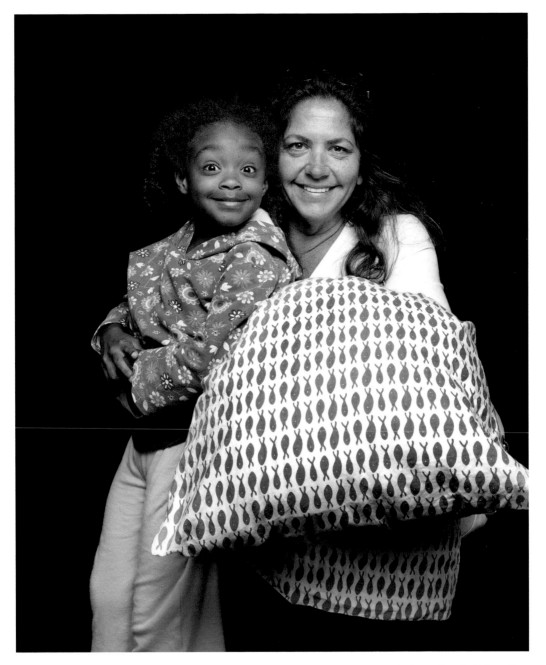

We love Lake Michigan and have had the great opportunity to enjoy it from both sides. Our summer vacations always consist of trips to Sister Bay in Door County and a few weeks' stay in Traverse City. —Peggy Brennan and her daughter, Lola, overnight passengers on the SS *Badger* ferry, Ludington, Michigan

Jeffery Curtis, captain of the SS *Badger* ferry, Ludington, Michigan

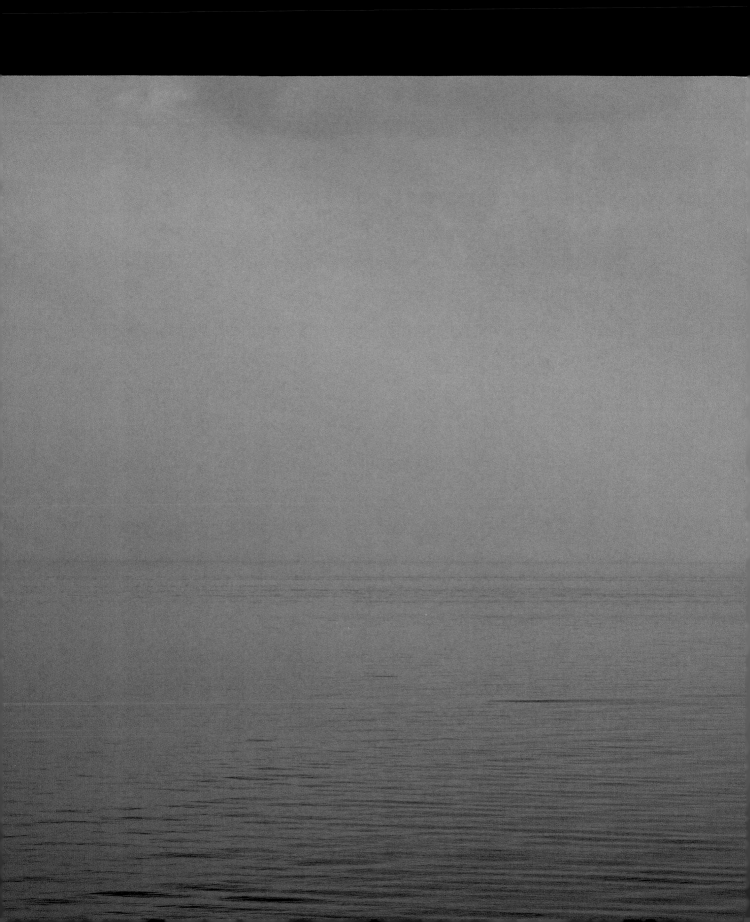

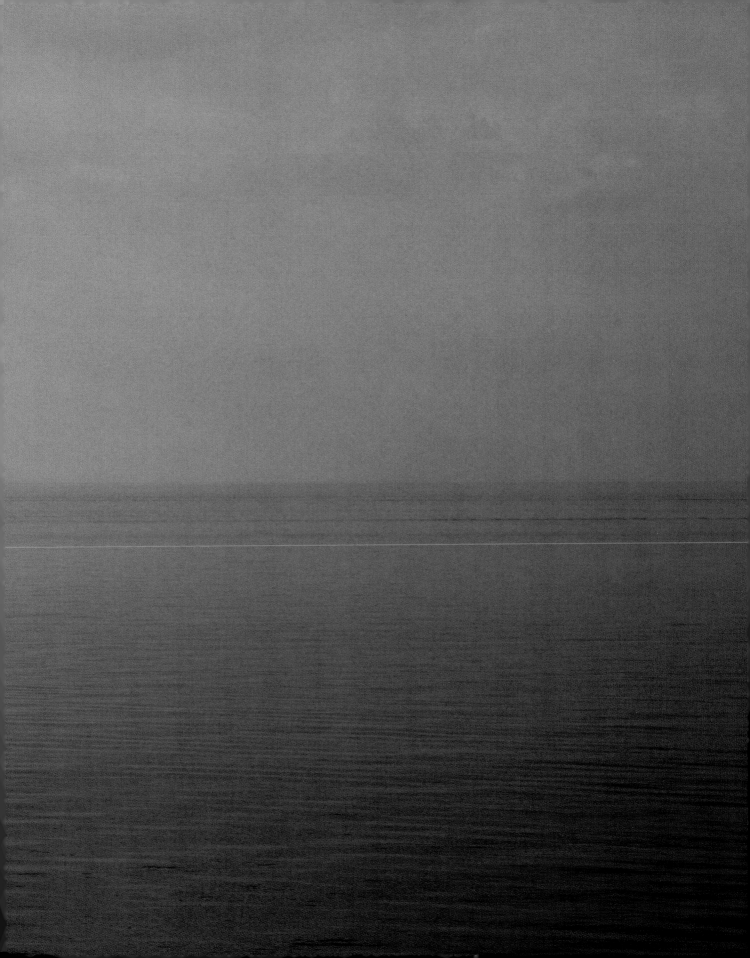

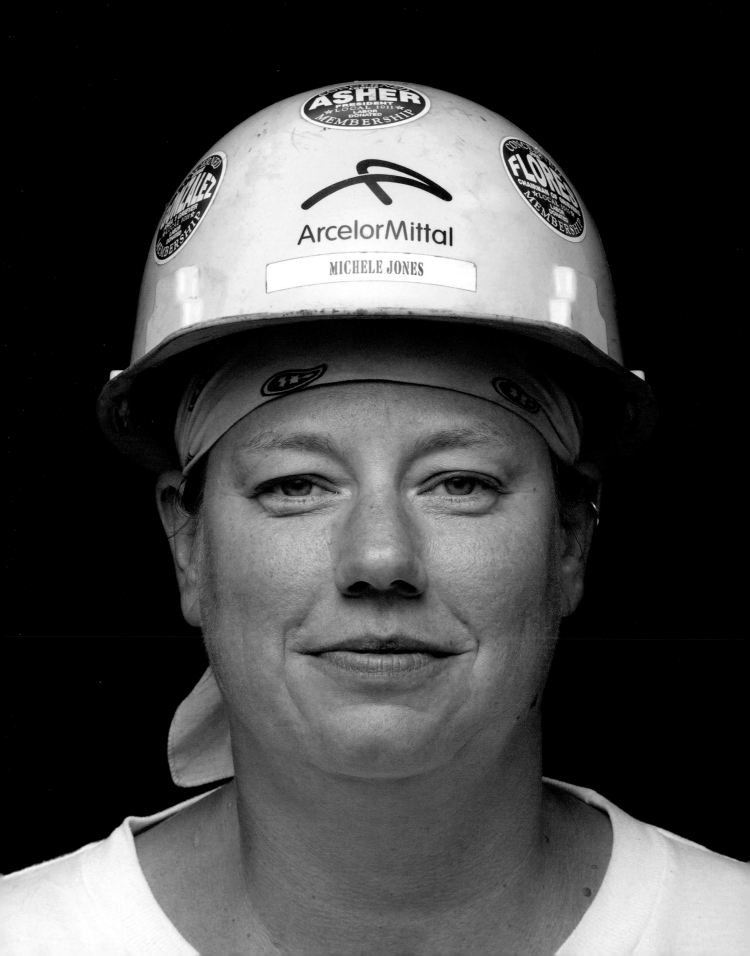

One of the most pressing issues that I ponder over on a regular basis is the unfortunate polluting of the lake. I, thankfully, work for a company that is very environmentally sound and adheres to many strict measures to ensure that our steel mill does not contaminate the water, air, wildlife, and surrounding area in any manner.

—Michele Jones, steelworker, East Chicago, Indiana

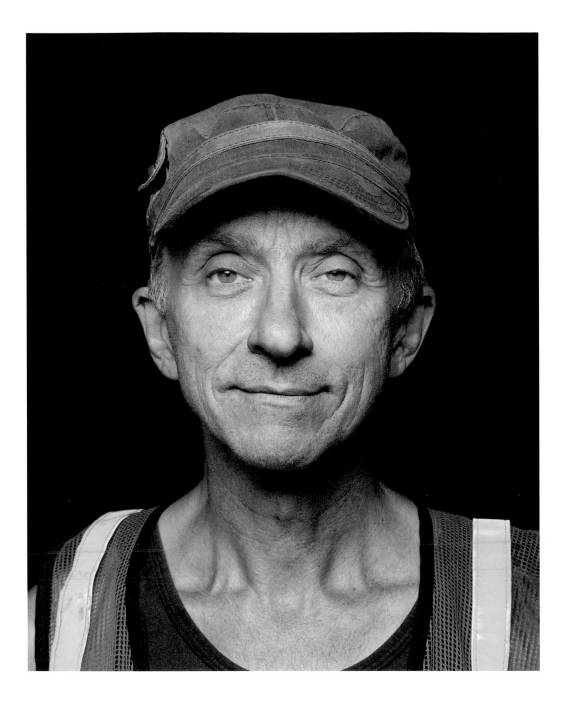

Tom Schwark (above) and Heiko Eggers (opposite), longshoremen, Milwaukee, Wisconsin

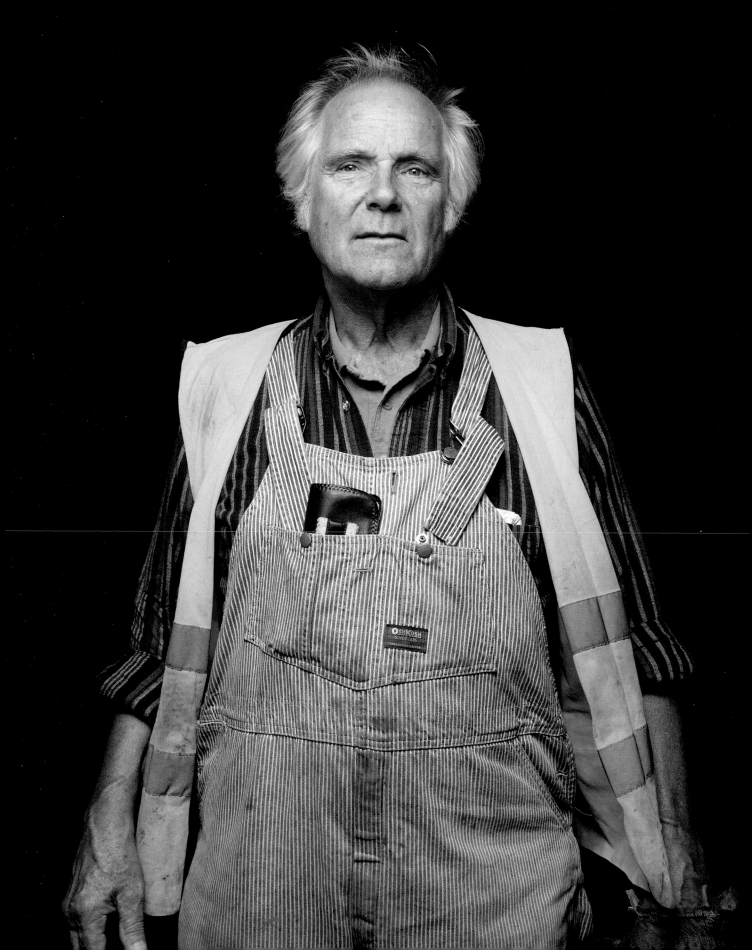

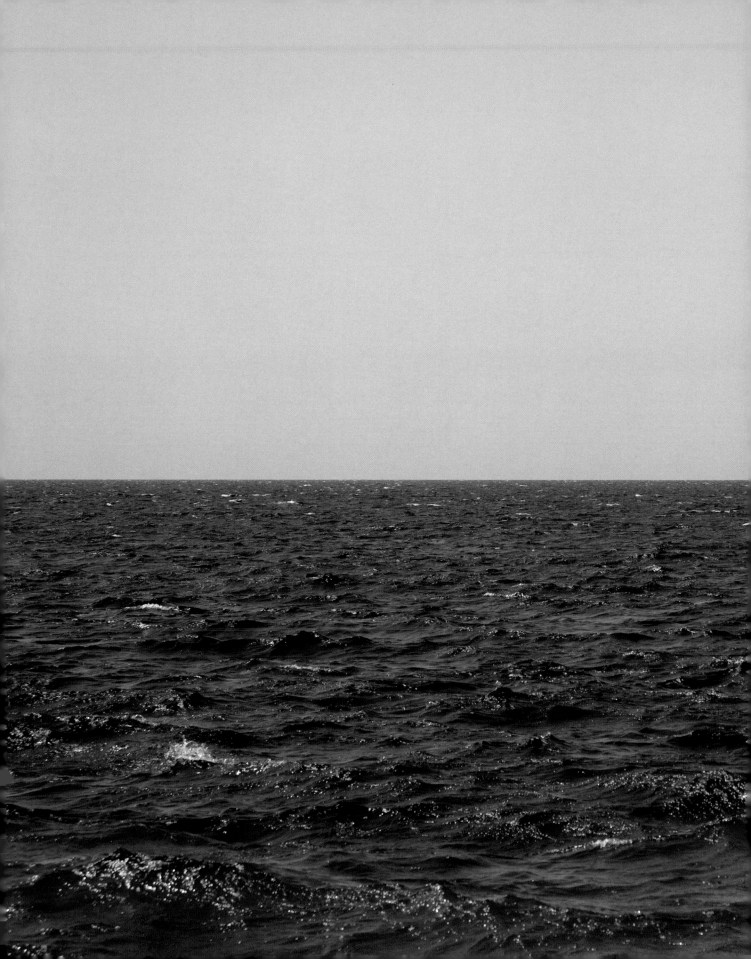

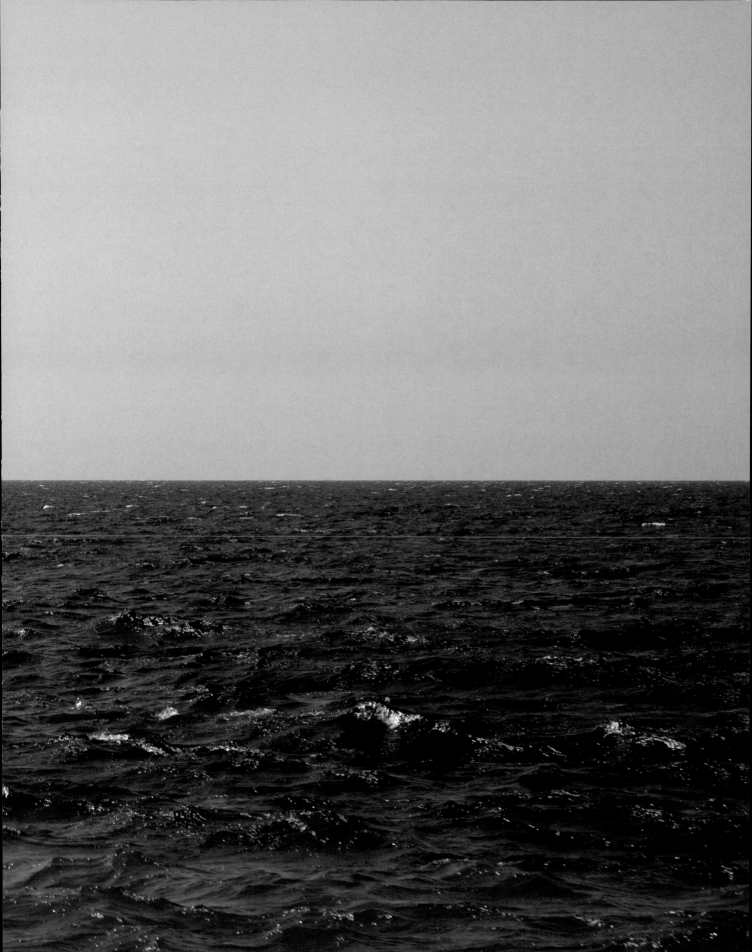

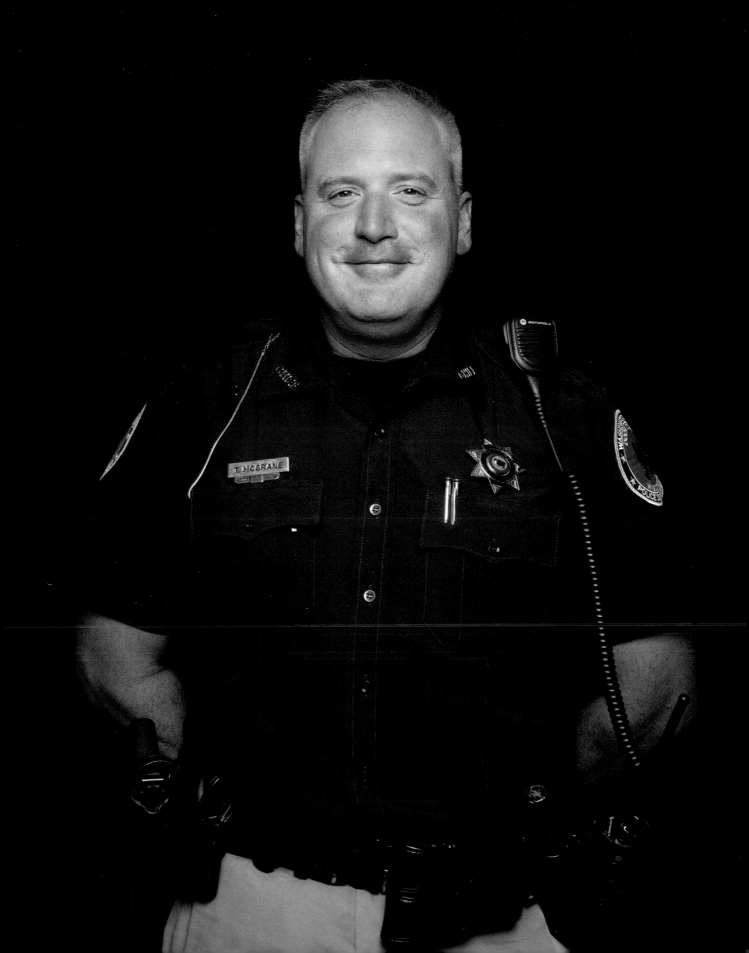

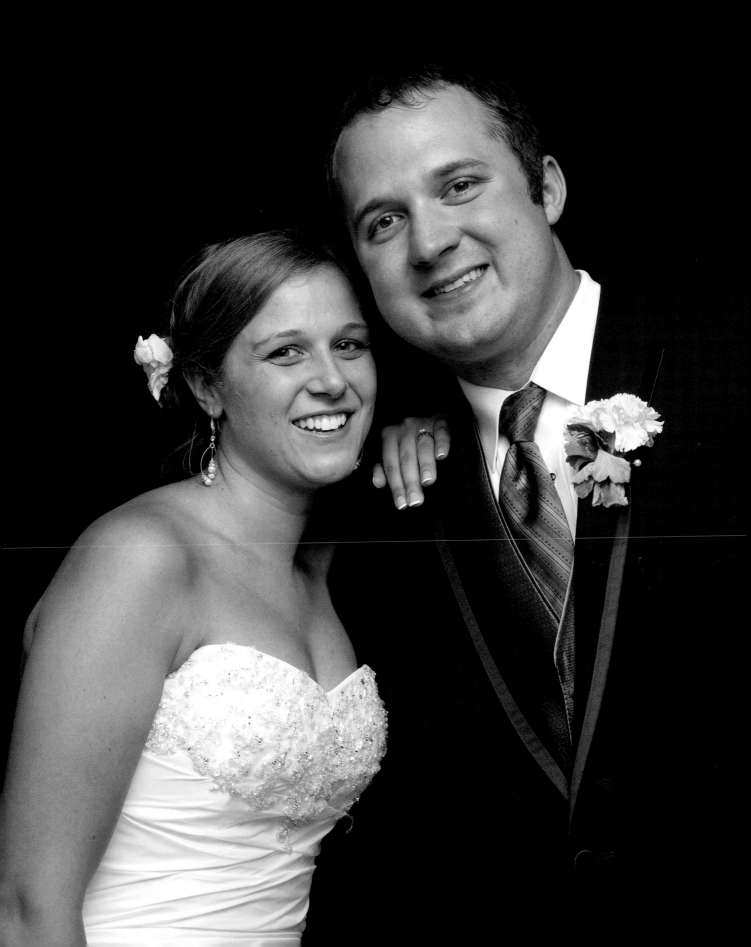

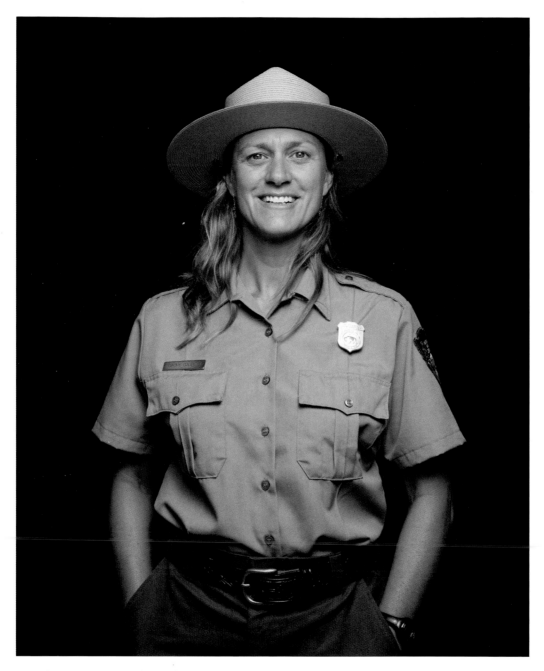

I am drawn to Lake Michigan for many reasons: people, ecology, scenery. The people around the lake love it and work to protect it. The ecology of the lake defines our state. The scenery takes our breath away. The lake, its shores, and its animals and plants are the most beautiful in the world. —Tammy Coleman, biology teacher and seasonal National Park Service ranger, Sleeping Bear Dunes National Lakeshore, Michigan

Tyler McGrane (opposite), chief of police, Washington Island, Wisconsin

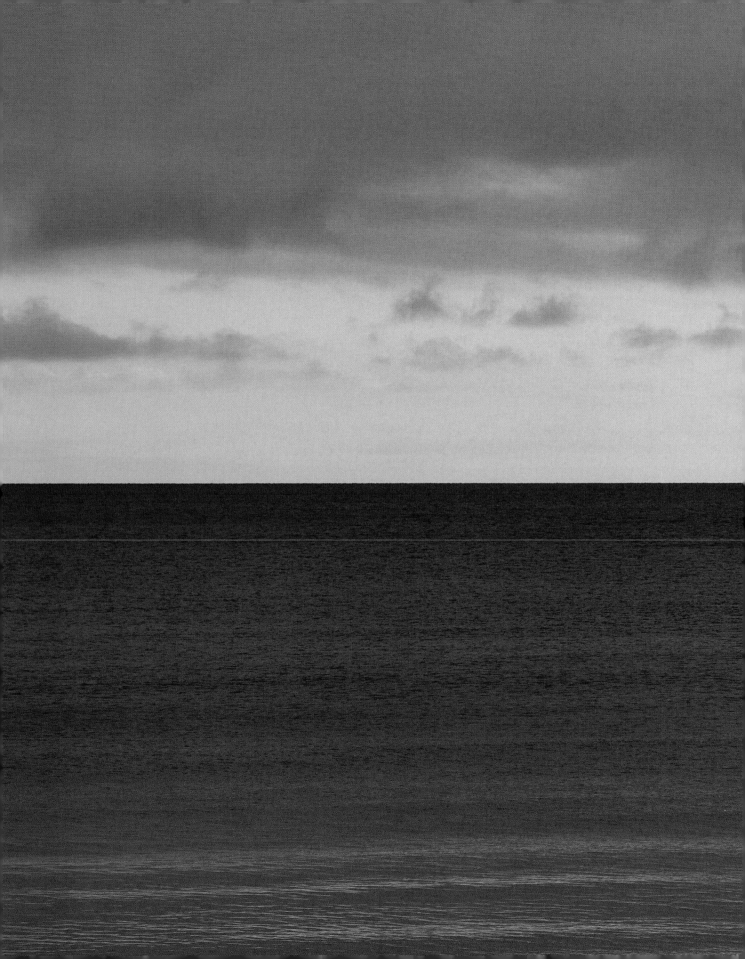

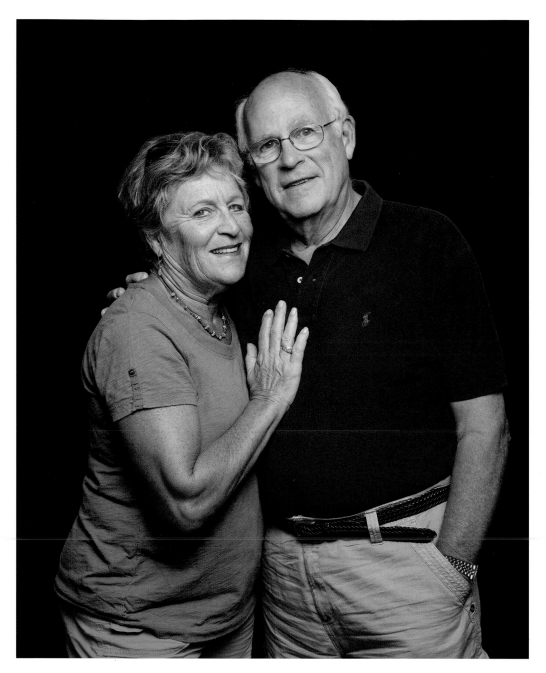

We love the "Michigan Ocean" and never take for granted the gift of living on this precious freshwater lake. All seasons offer sights and sounds of nature at its best. Sunrises, moonrises, winter's frozen vapor rising, the pink skies above. —Barbara Bode Schmutzler and David Schmutzler, residents on Lake Michigan, Port Washington, Wisconsin

Ashley and Adam Sohasky (opposite), newlyweds whose wedding reception was on the lake, Traverse City, Michigan

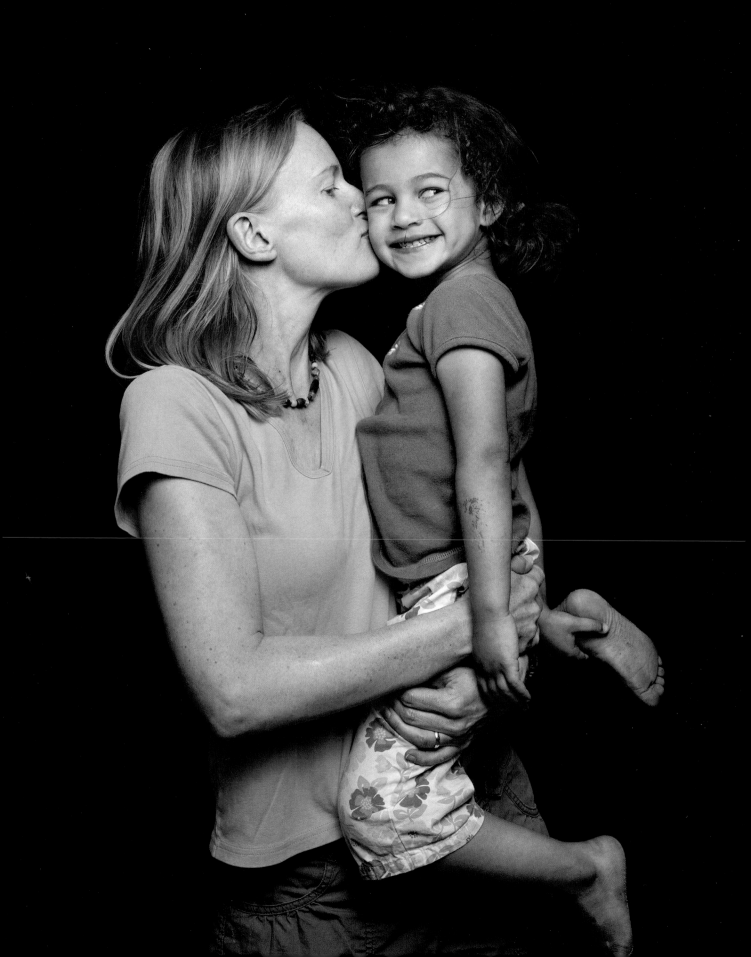

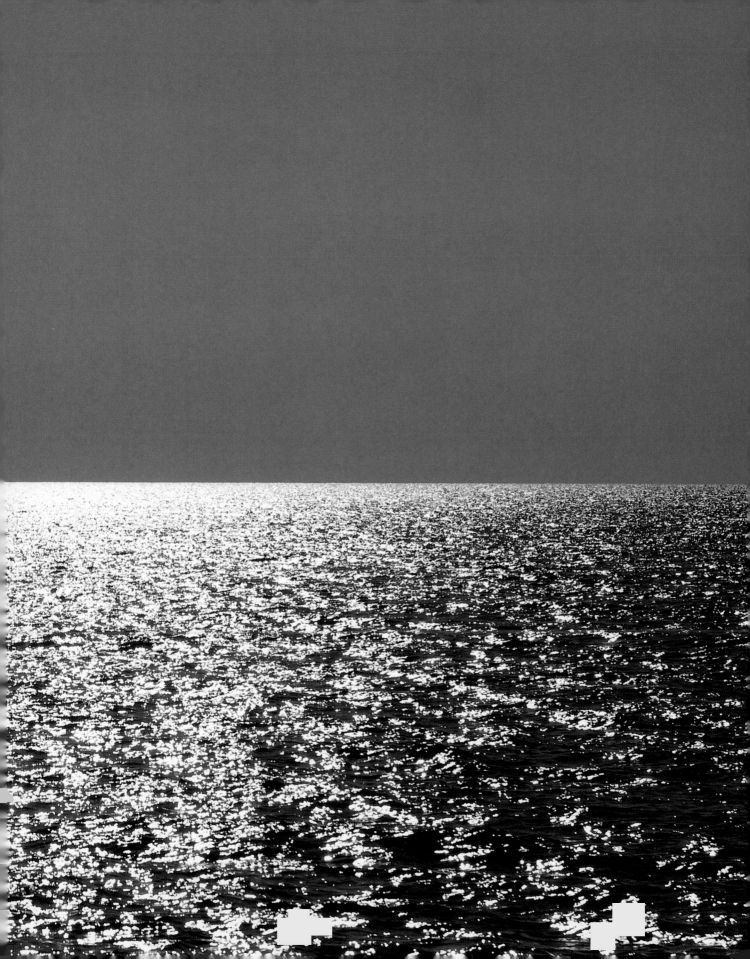

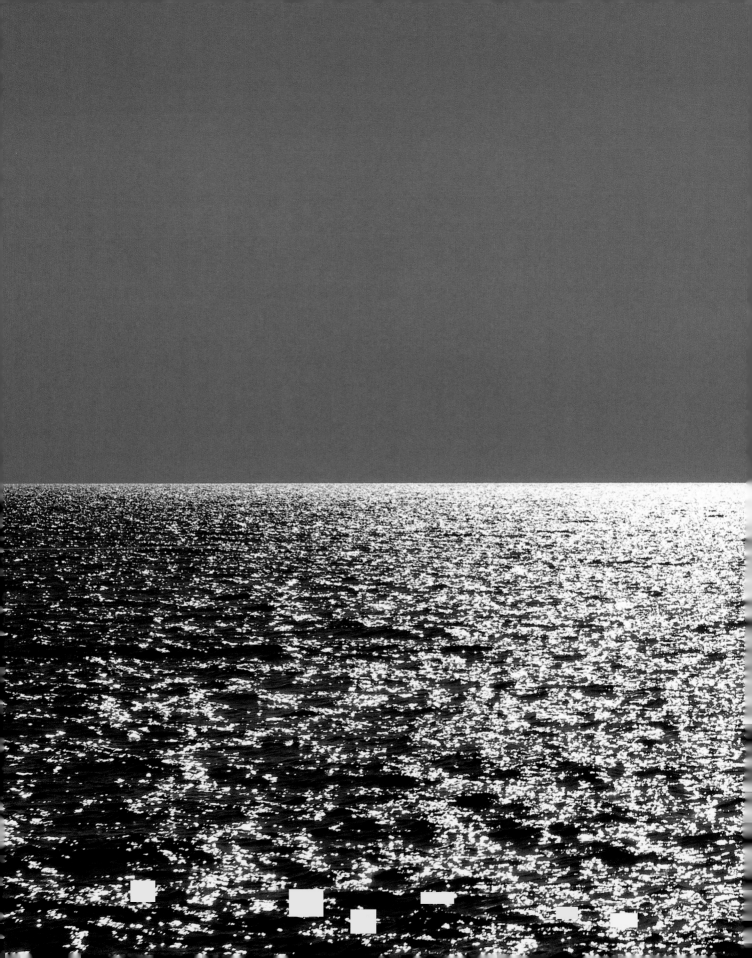

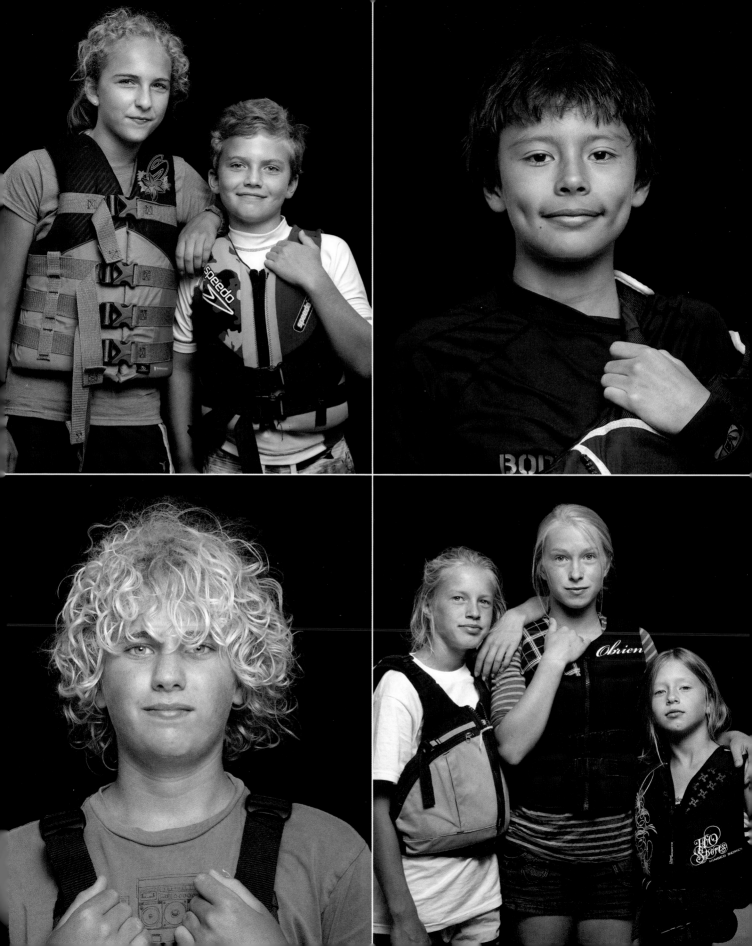

What matters most to me about the lake is how intimately important it is in my personal and family sense of place and well-being; its power is centered during calm and storm; its long reach is to both my ancestors and my descendants; it has been terrifying and comforting all at the same time; its beauty mystifies and inspires every time I come upon it in the hurrying of my life.

—Frank Ettawageshik, Native American leader and water rights advocate, Harbor Springs, Michigan

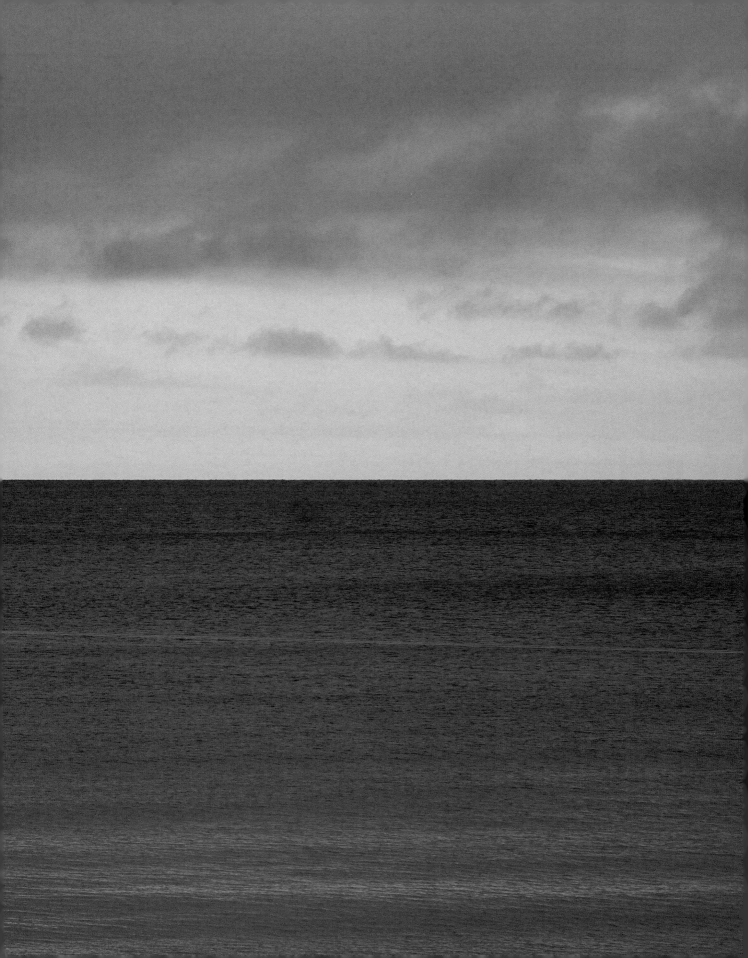

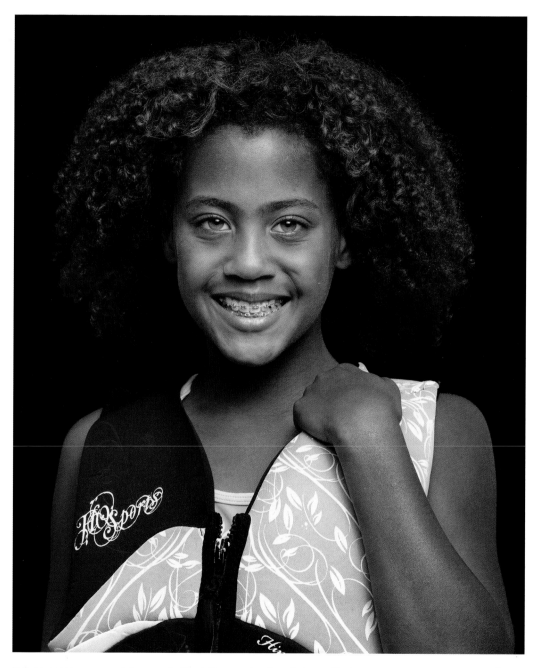

What matters most to me is that the water level doesn't drop anymore so we can keep jumping off the dock, and that the lake stays clean. —Kaela Steele, sailing student at Ephraim Yacht Club, Ephraim, Wisconsin

Ephraim Yacht Club sailing students, Ephraim, Wisconsin (opposite, clockwise from top left): Alyssa and Jonathan Graham; Nicolas Gonzalez; Ingrid, Gretchen, and Annika Pearson; Steven Richter

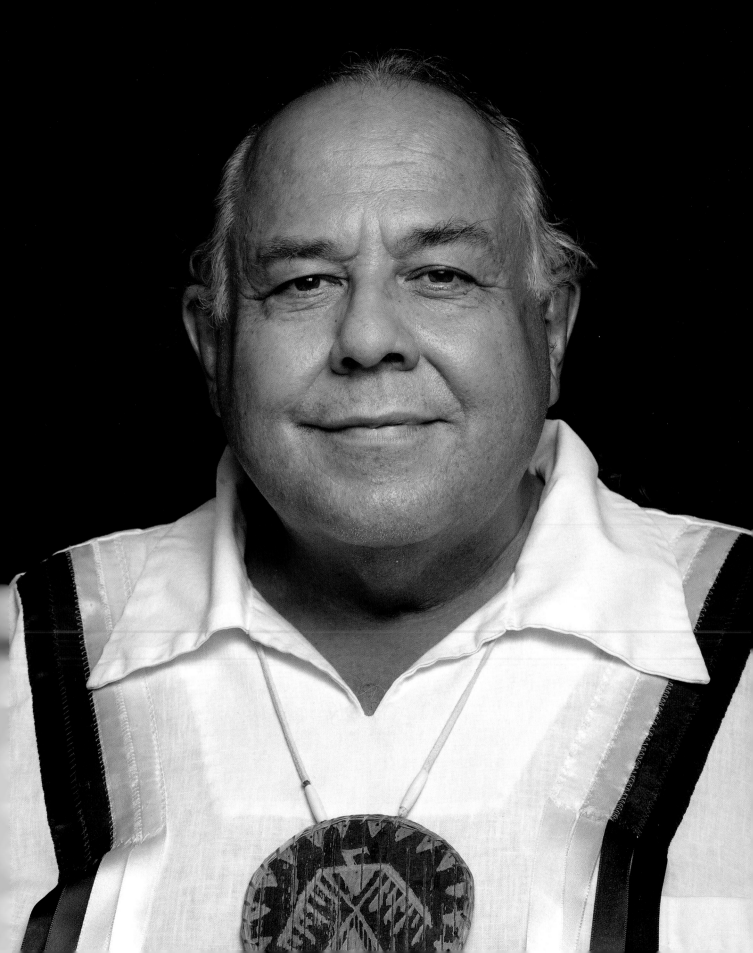

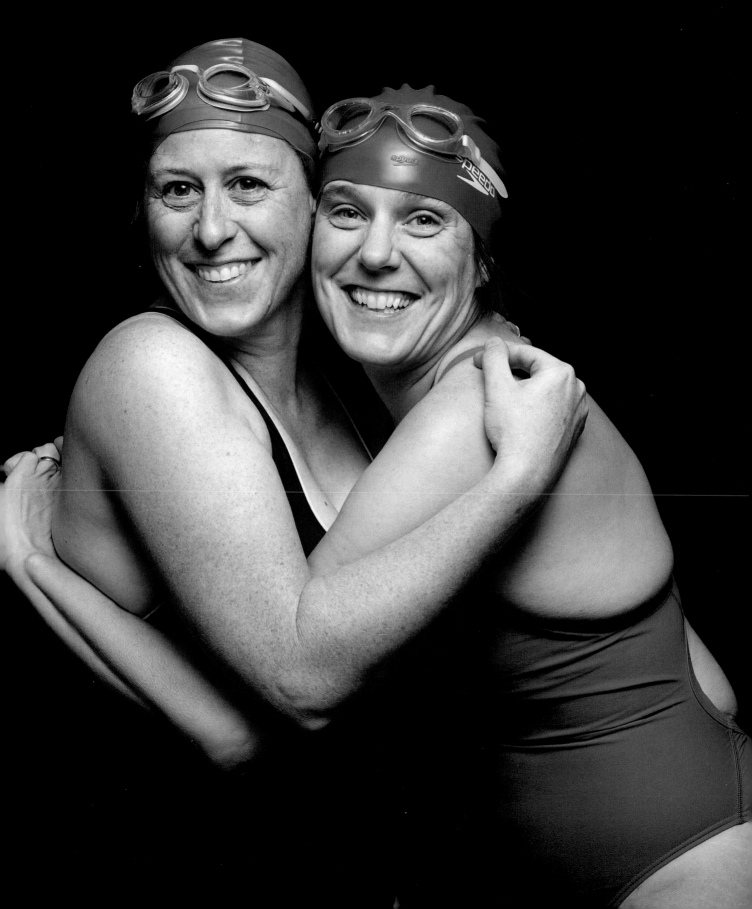

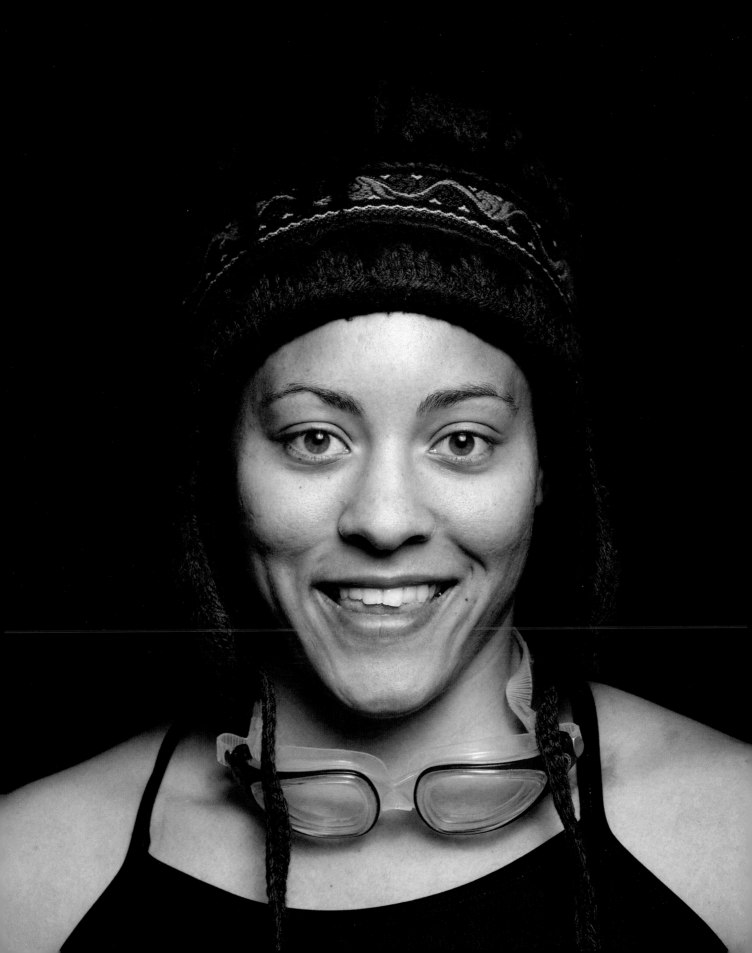

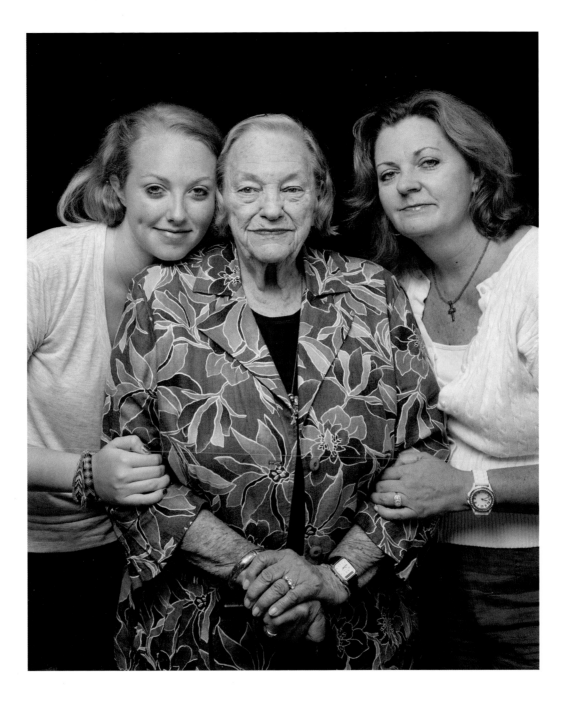

Silke Cole and her daughter, Lena (opposite), visitors to Big Bay Park, Whitefish Bay, Wisconsin

Piper Grant, Kay Piper, and Ginnie Piper Grant (above), longtime vacation property owners, Harbor Springs, Michigan

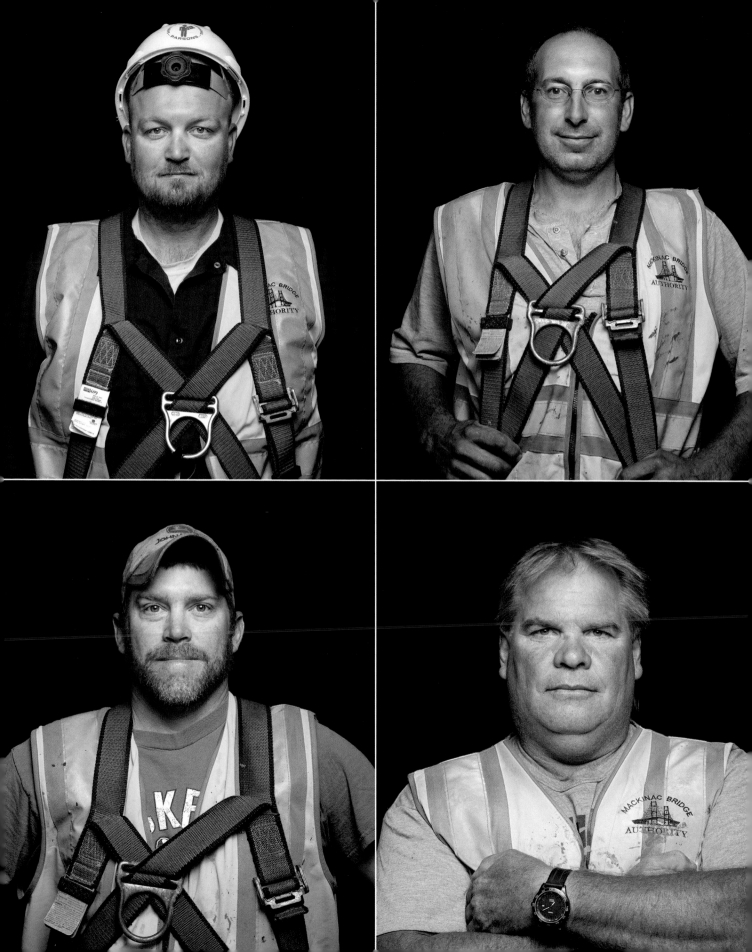

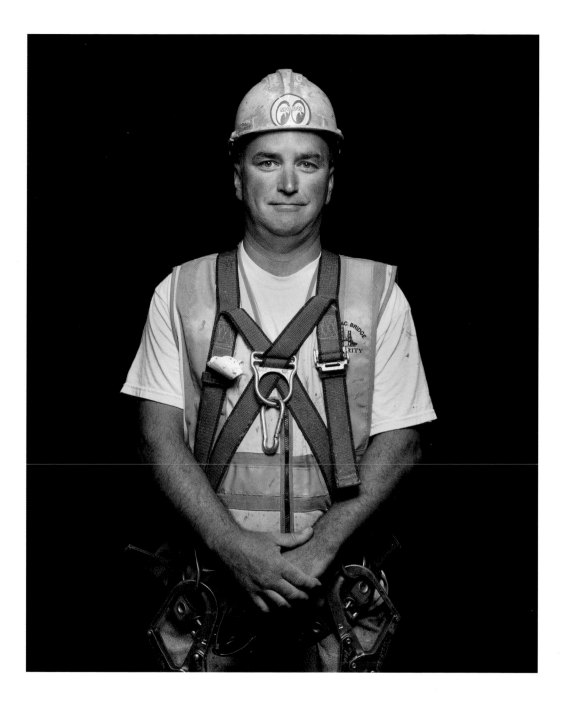

Mackinac Bridge workers, St. Ignace, Michigan: Todd Mayer (above) and (opposite, clockwise from top left) Ned McLennan, Keith Ginop, Dan Sheber, Gordon Shunk

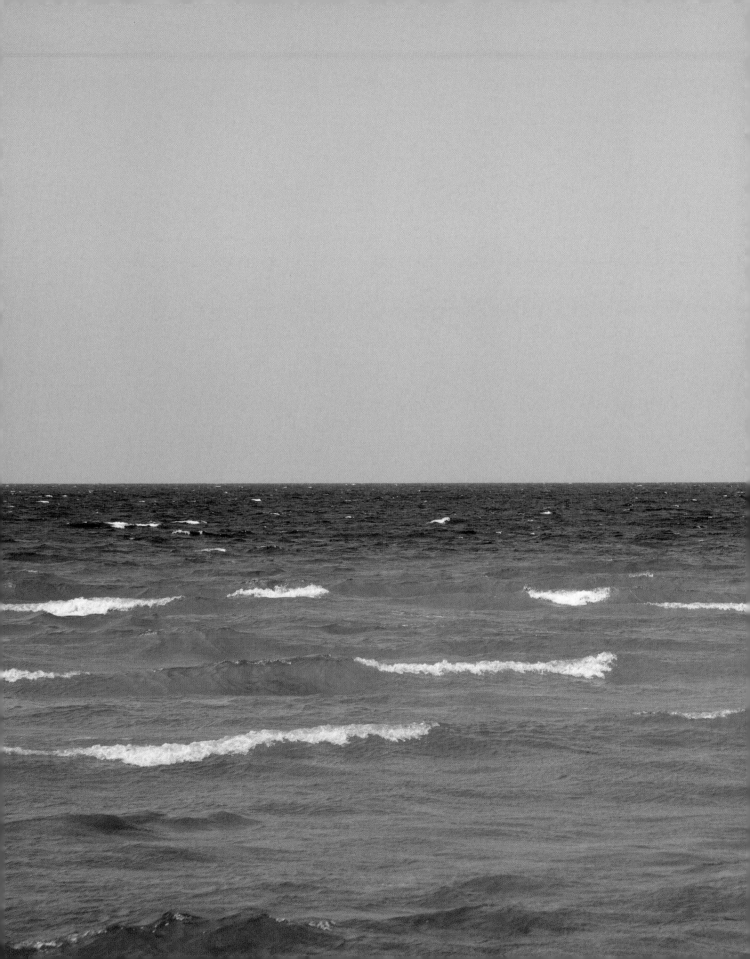

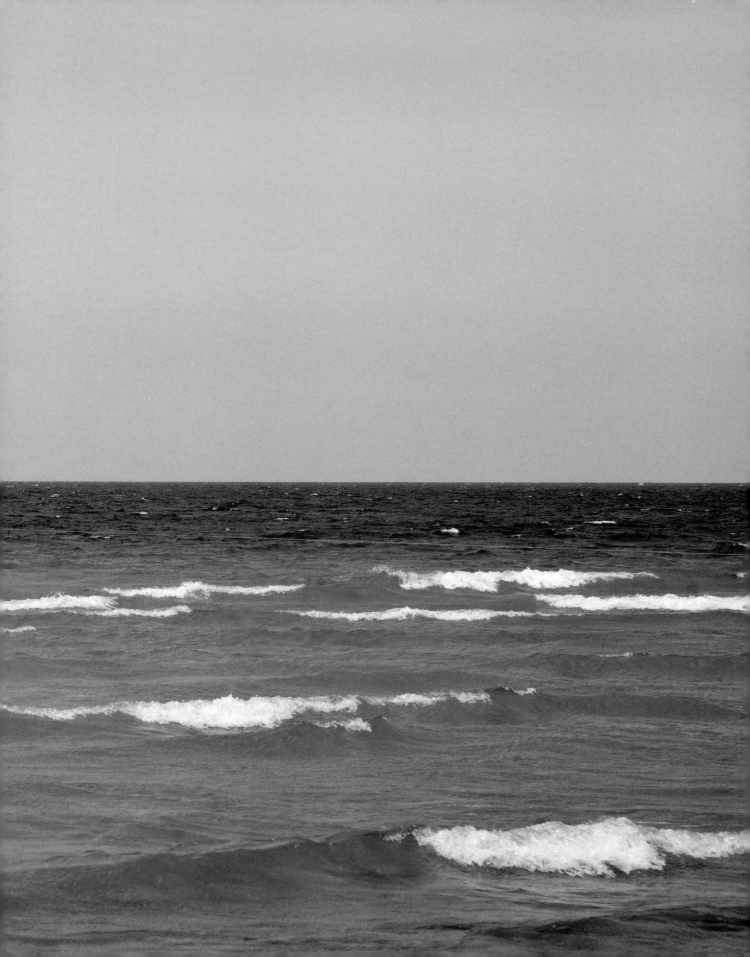

When I am out in the water looking at the horizon, I think of the vastness of the lake and how incredibly lucky I am to be a part of it—and the world. When I look at the shoreline, I gain perspective and am better able to appreciate a city I adore without feeling swallowed by its busyness. I guess the lake is my house of worship and my therapist!

—Julia Talbot (quoted here) and Liz Libby, members of the Point Swimmers, Promontory Point Park, Chicago, Illinois

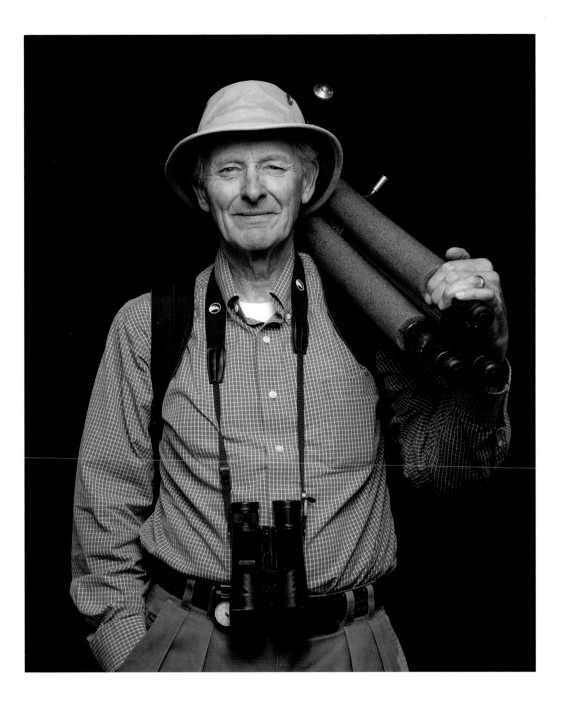

Symeon Robinson (opposite), volunteer for Alliance for the Great Lakes' Adopt-a-Beach program, Milwaukee, Wisconsin

Chuck Sontag (above), educator and retired biologist, Manitowoc, Wisconsin

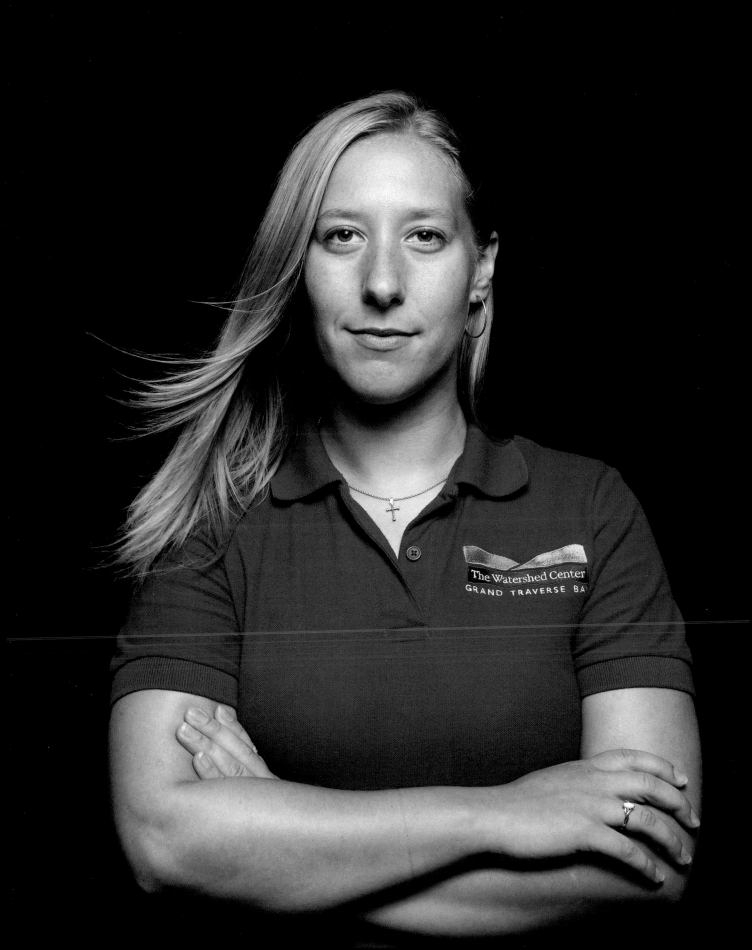

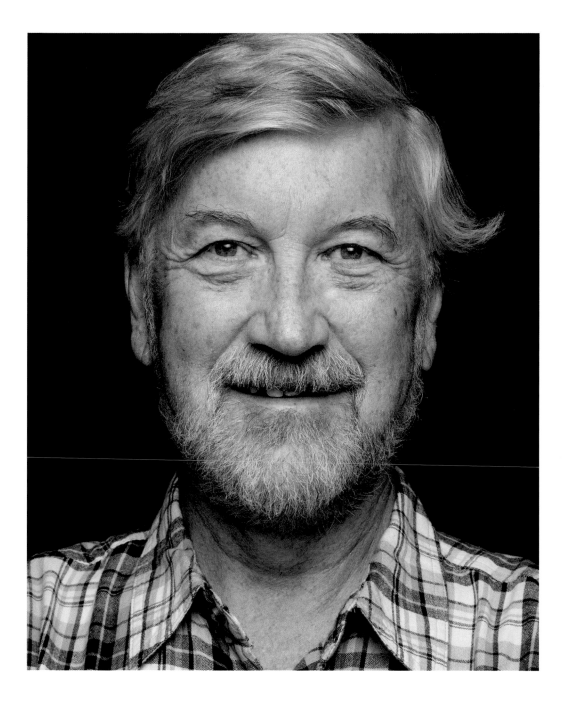

Maureen McManus (opposite), program associate at The Watershed Center Grand Traverse Bay, Traverse City, Michigan

Tom Kelly, executive director of the Inland Seas Education Association, Suttons Bay, Michigan

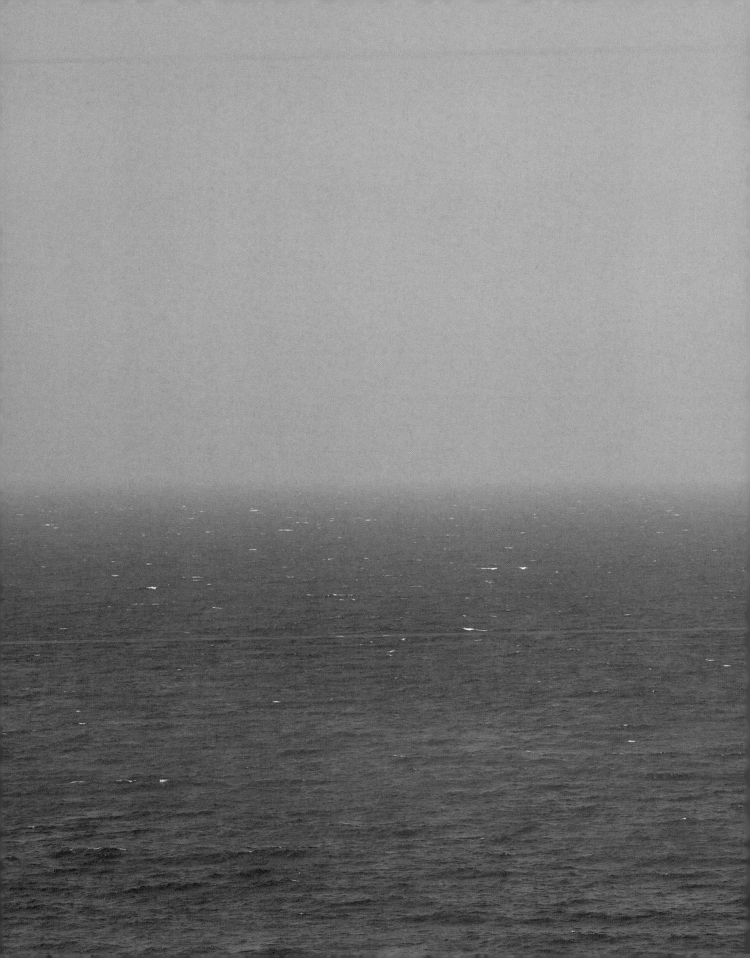

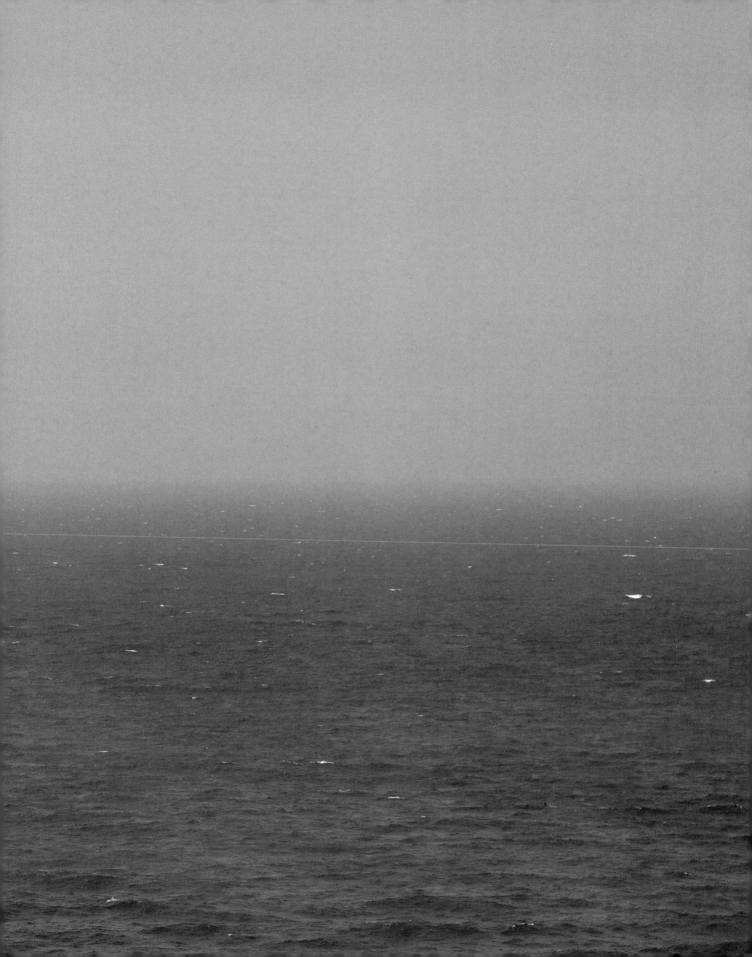

I ride my bike onto a jetty from where I can see the Milwaukee skyline and simultaneously the vast expanse of the lake. I find a bench overlooking the water and often I read. Or not. Sometimes I just sit, taking in the beauty of the scene before me.

—John Ruebartsch, visitor to Veterans Park, Milwaukee, Wisconsin

When I see the lake, I don't just see the water and animals and tourists that use the lake now. I think of when it was a highway for commerce in the eighteenth century and the importance it held for the lives of Native people for thousands of years. —Andrew Kercher, historic interpreter at Colonial Michilimackinac, Mackinaw City, Michigan

Historic interpreters at Colonial Michilimackinac, Mackinaw City, Michigan (opposite, clockwise from top left): LeeAnn Ewer, James Evans, Madeline Hyde, Benjamin Lee Wemigwase

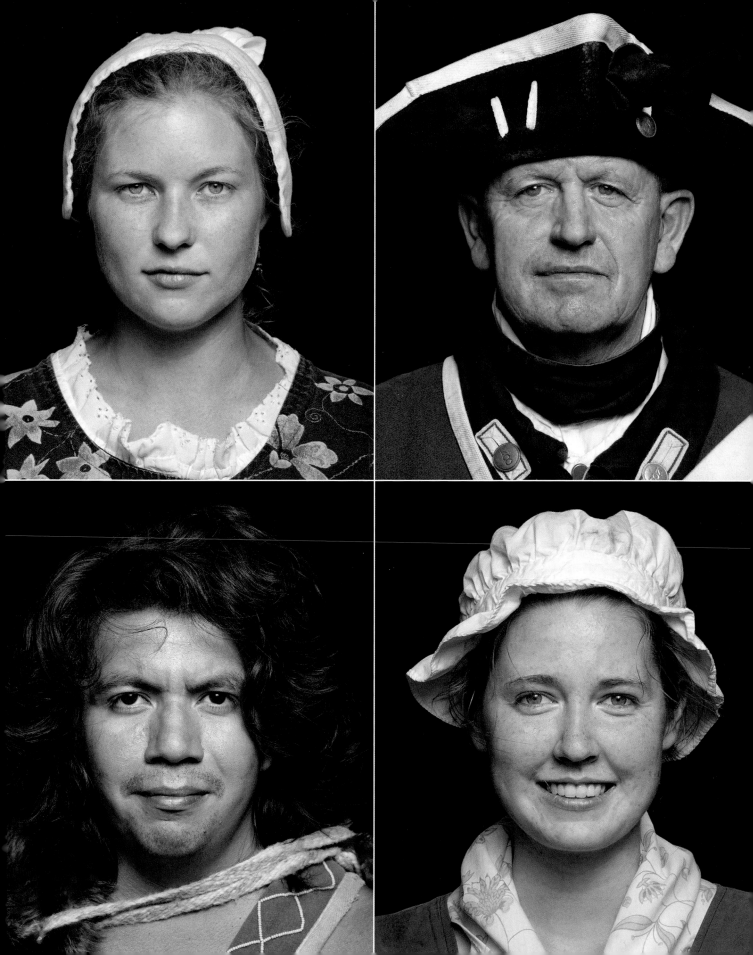

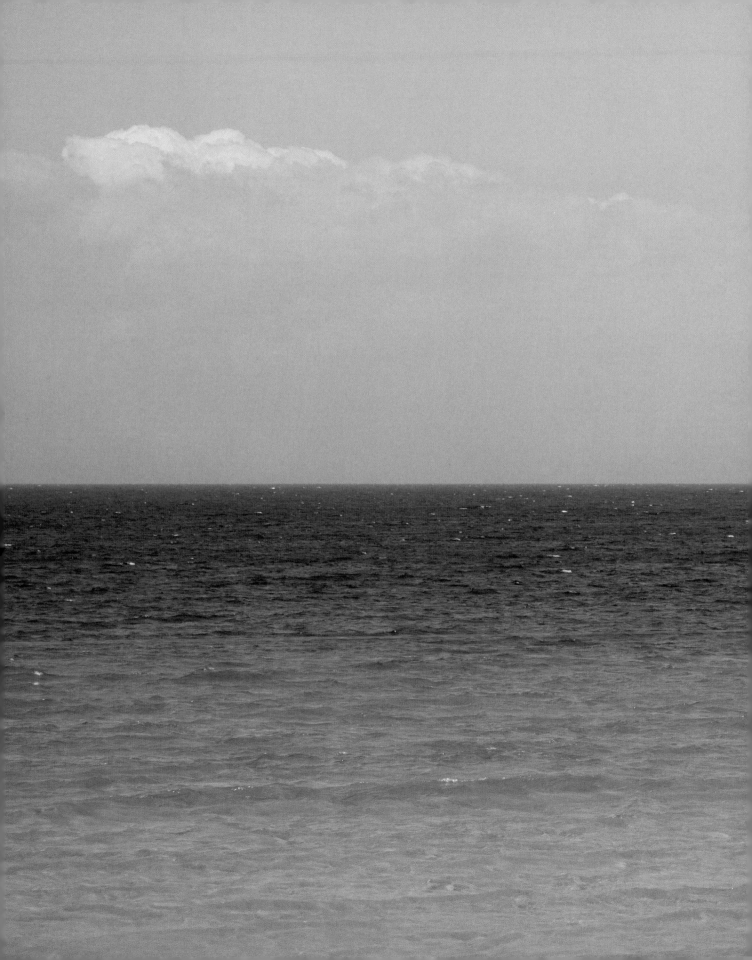

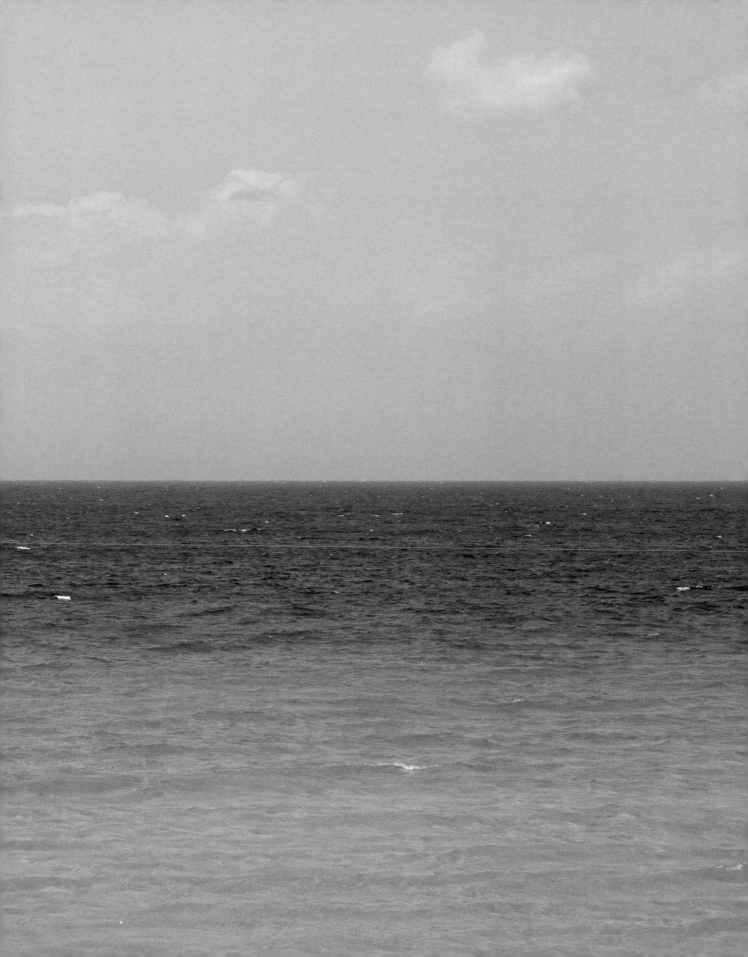

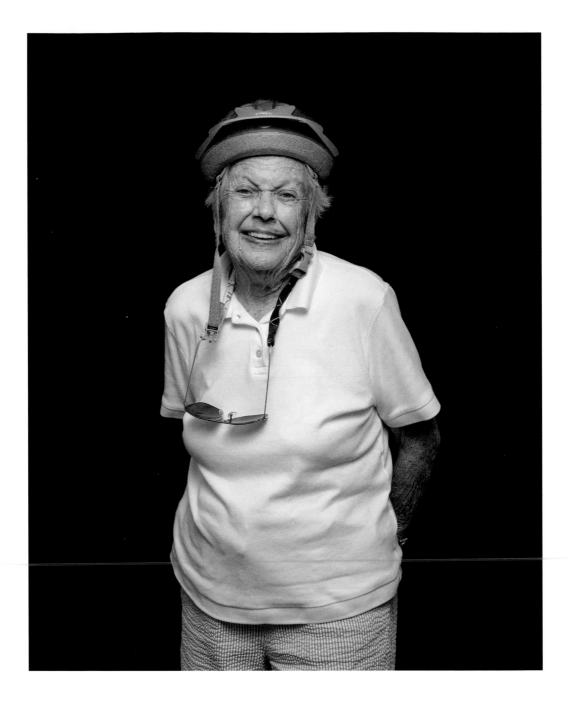

Dorothy Jane Hartzell (above), cyclist, Harbor Springs, Michigan

Dulce Duque (opposite), skateboarder, Milwaukee, Wisconsin

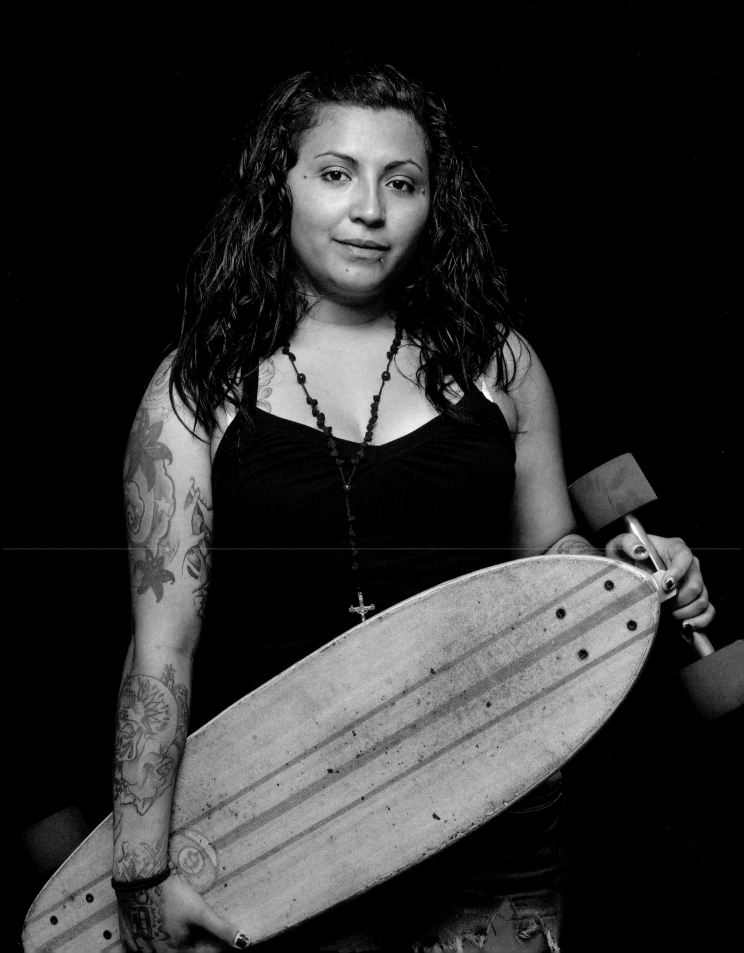

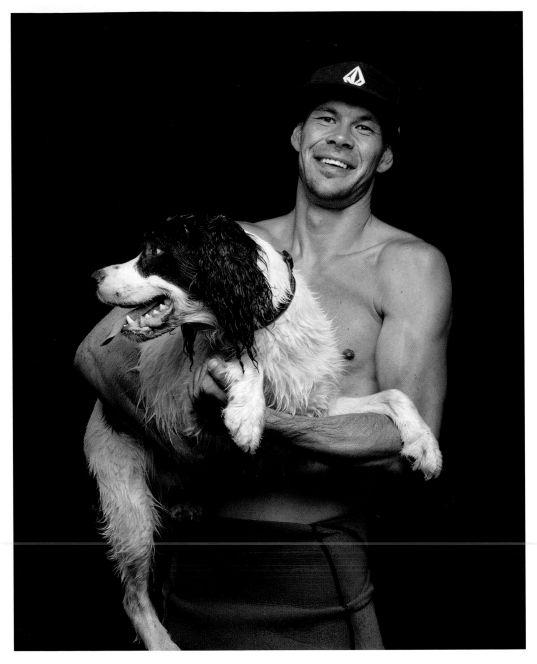

Well, to be brief, I love an underdog . . . an unsung hero . . . things hidden in plain sight. . . . [Lake Michigan] keeps me in shape. It centers me. The more I partake, the more I take ownership. I now sometimes refer to it as "my lake" and I wish more people did, too. —Andrew F. Wallus, surfer (and Jerry), Big Bay Park, Whitefish Bay, Wisconsin

Robert and Chris DeRobertis (opposite), visitors to Montrose Beach Park, Chicago, Illinois

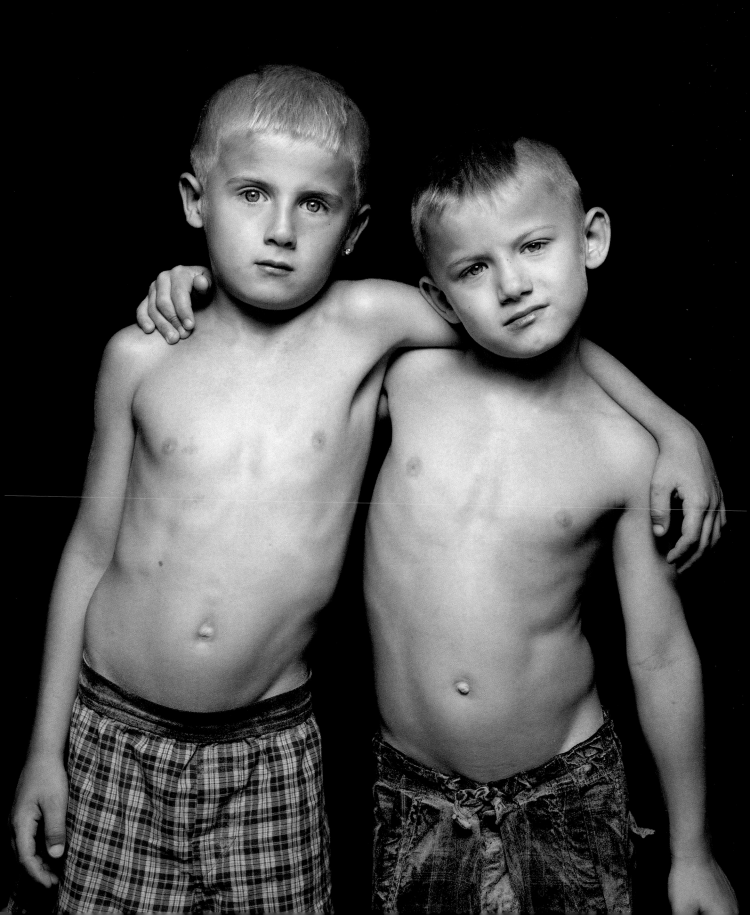

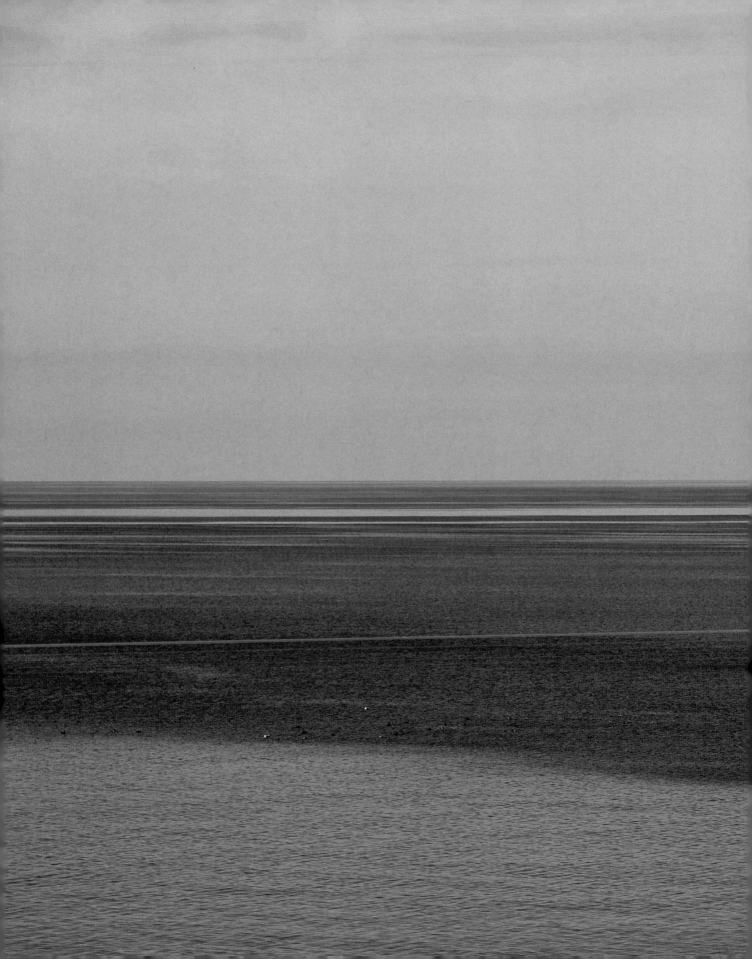

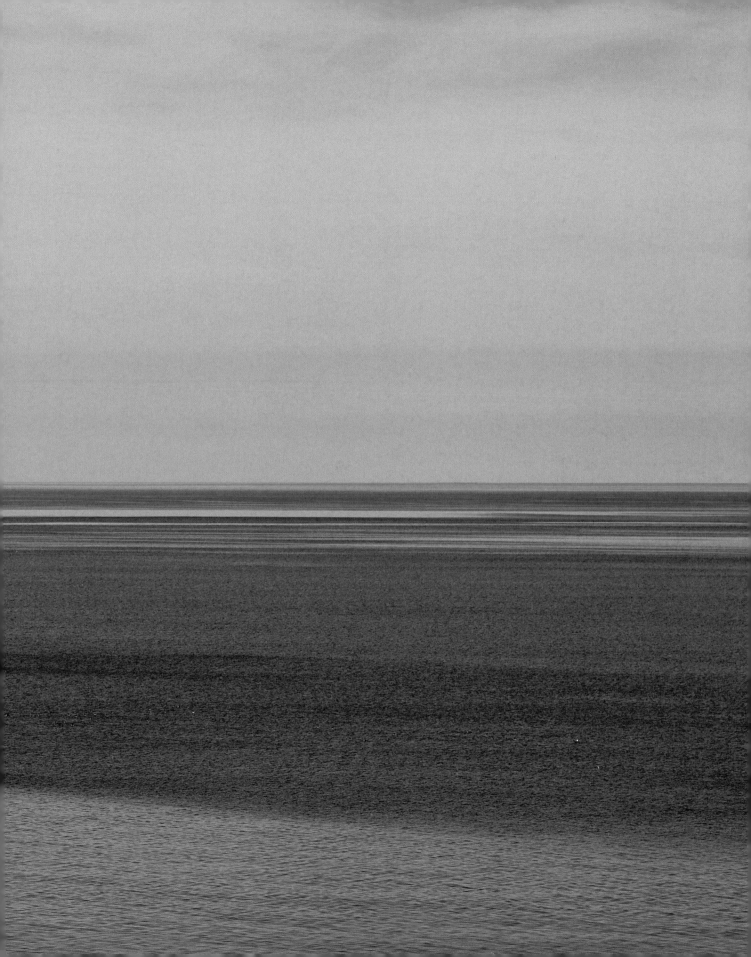

As a child I learned about becoming a woman through beach time and sandcastles in South Haven with my grandmother. I learned about how to be a fisher(wo)man—to respect and admire nature—with my dad and uncles on a boat miles away from shore. Over one summer, this body of water taught me about my own strength and how to be resilient. I overcame the biggest obstacles I have ever faced—entirely alone on this lake. I was left with Lake Michigan and only Lake Michigan for so many days and so many nights. I praised her one day and cursed her the next—but I always wanted her close, I always respected her, I was always thankful for her—and always will be.

—Jenn Gibbons, who rowed around Lake Michigan for fifty-nine days for breast cancer awareness, Chicago, Illinois

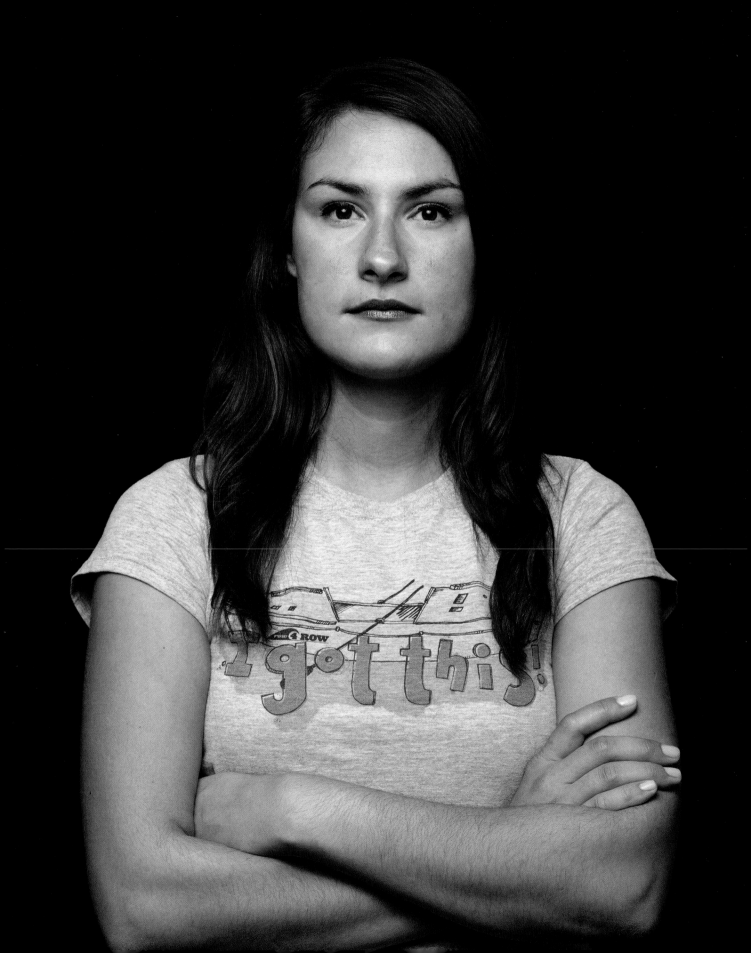

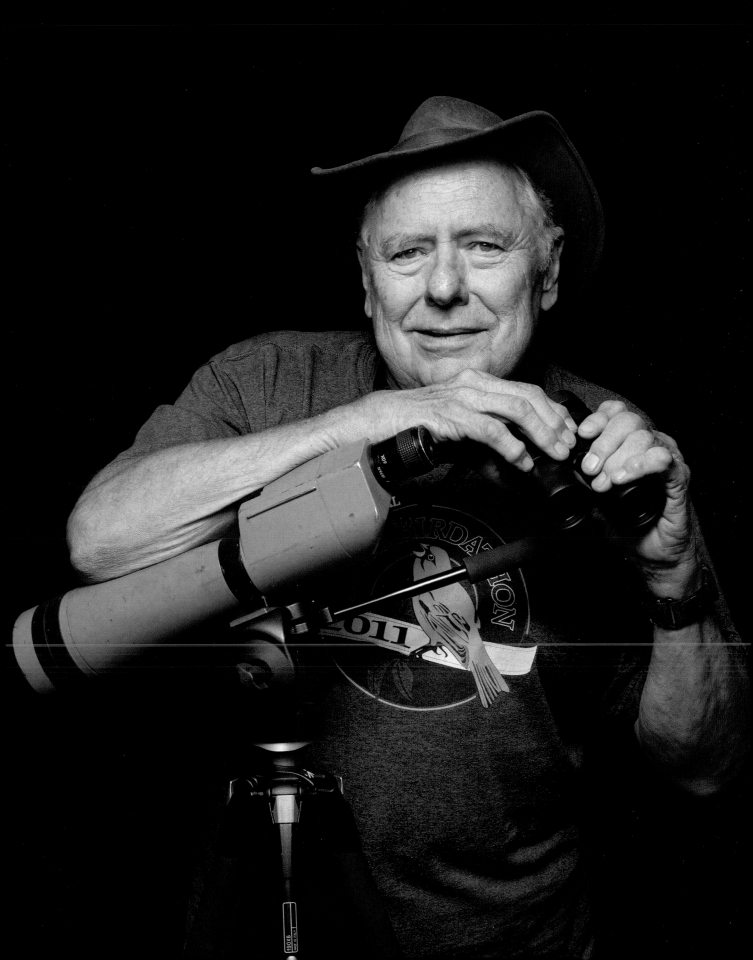

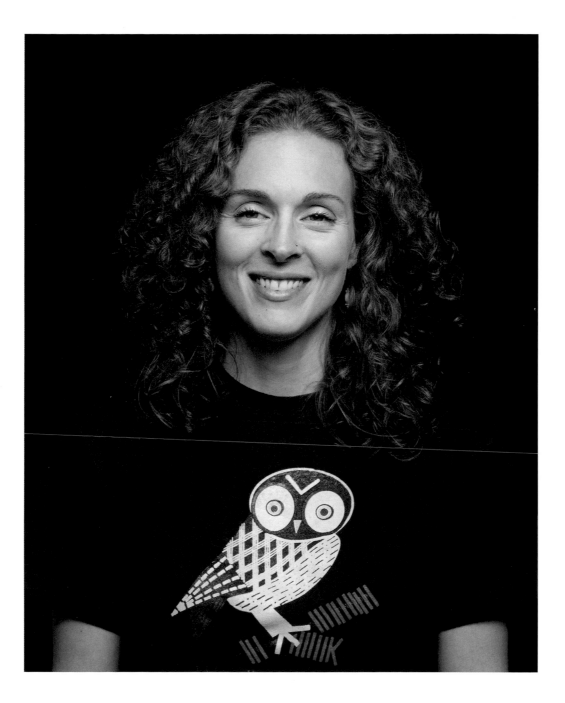

Chuck Nelson (opposite), birder and naturalist, Benton Harbor, Michigan

Jessica Johnsrud (above), assistant director at the Woodland Dunes Nature Center
and Preserve, Two Rivers, Wisconsin

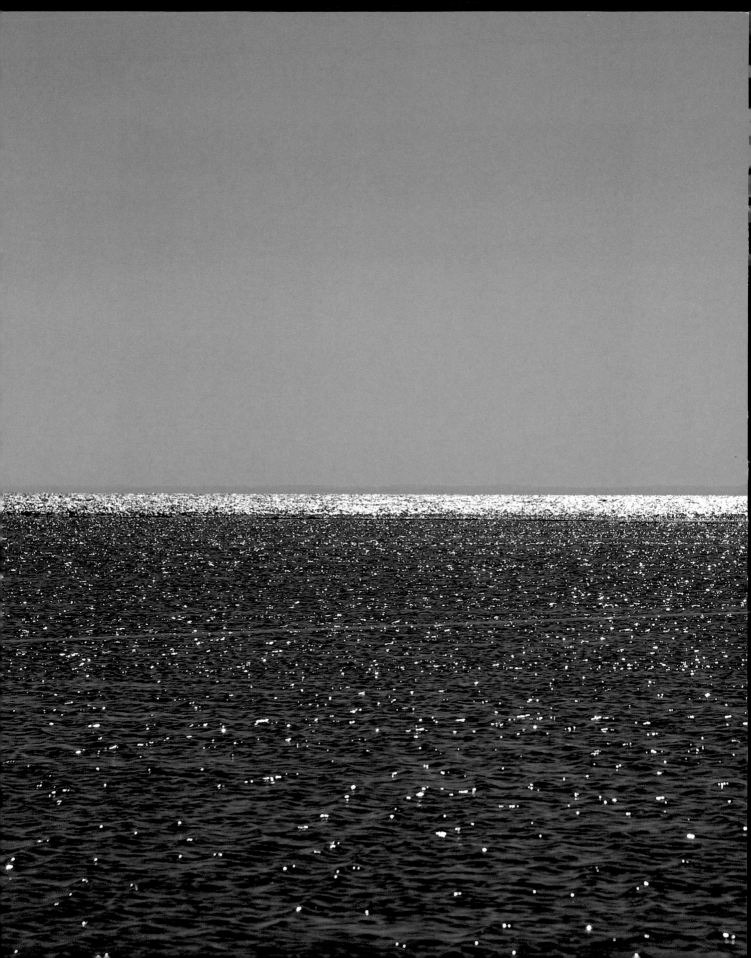

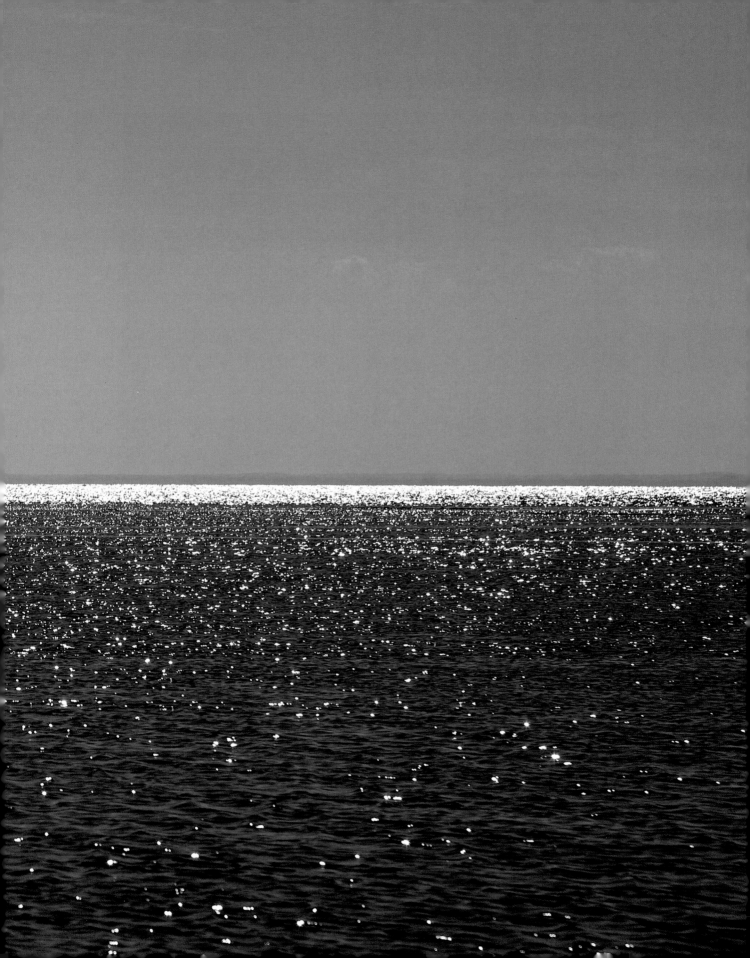

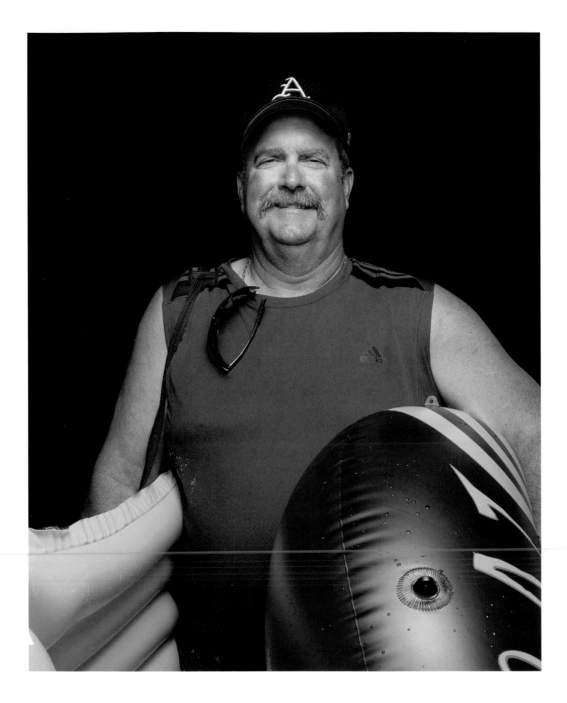

Steve Apted Jr. (above), visitor to Holland State Park, Holland, Michigan

Earl and Charlese West (opposite), visitors to Whihala Beach, Whiting, Indiana

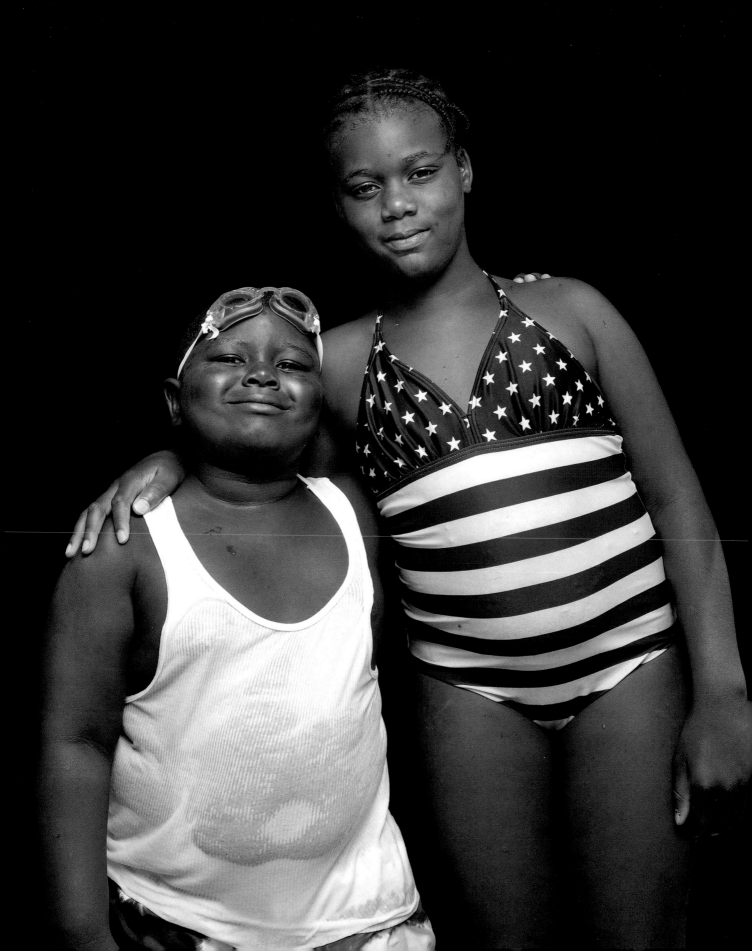

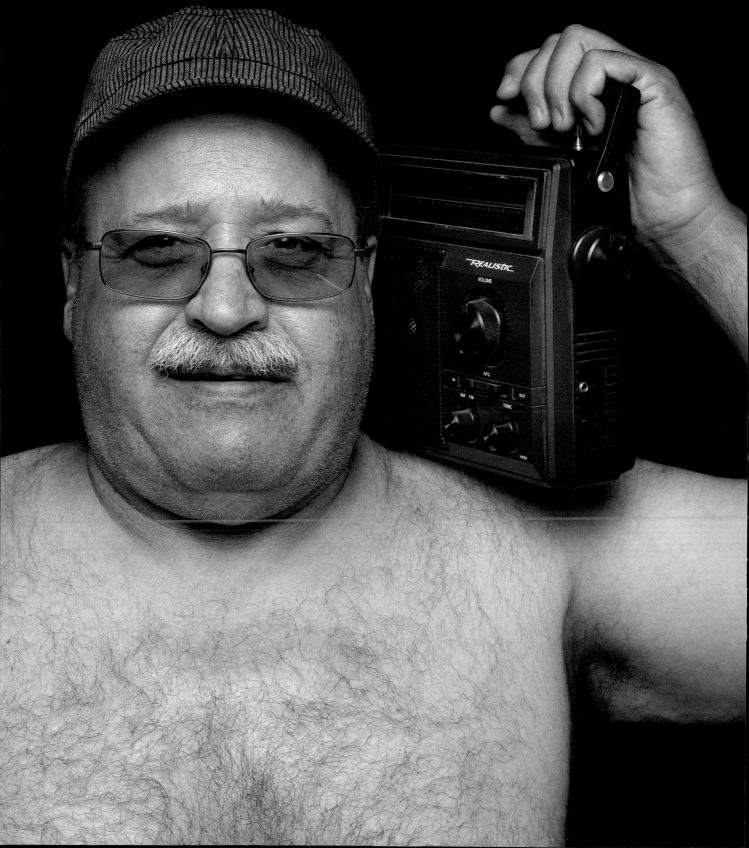

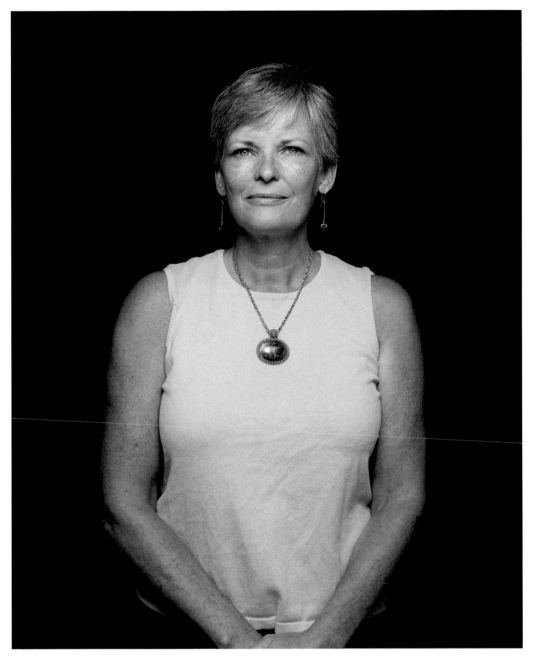

When I stand by the open waters, I can almost feel her breathing. The methodical waves sing a song as they kiss the shore, or whistle and slap against the bordering rocks, licking away bits and pieces back into the waters where they settle to the bottom. I dance on the sandy bottoms. —Catherine Allchin, volunteer for the Fox Island Lighthouse Association, Traverse City, Michigan

Rene Gonzalez (opposite), visitor to Whihala Beach, Whiting, Indiana

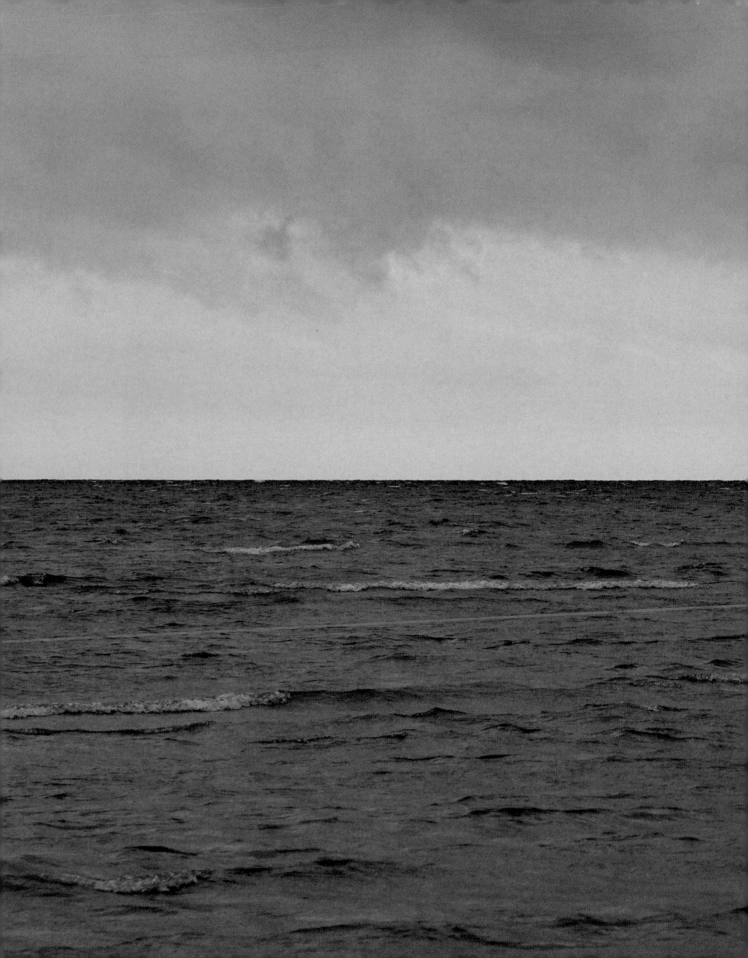

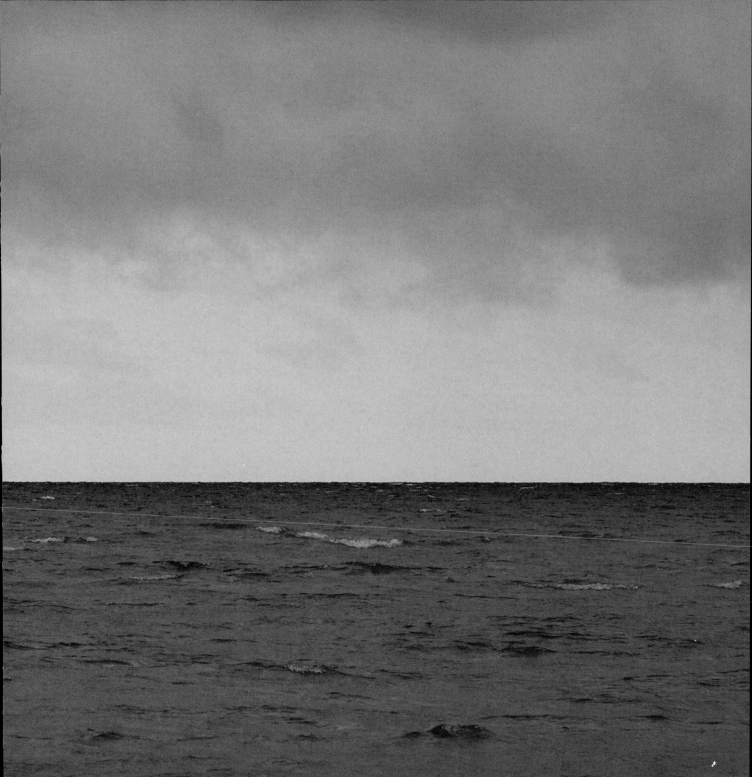

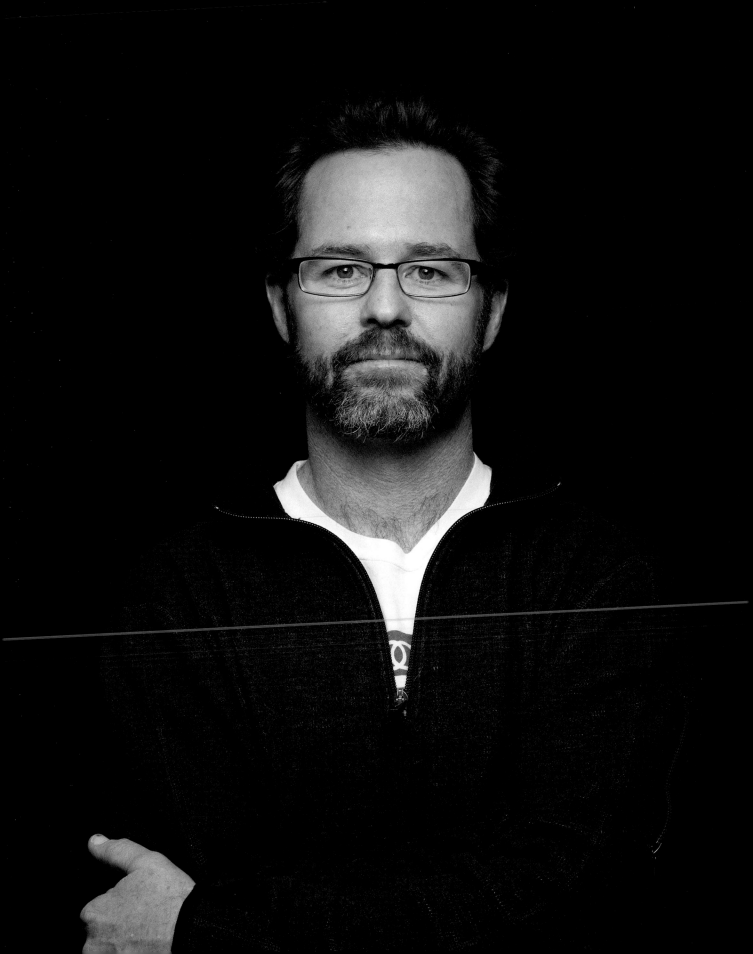

Whether someone has seen Lake Michigan once or a thousand times, the first time they see it—and I mean truly see it—I want the lake to make a good impression. A lasting impression that keeps them coming back to find a new canvas every time. I want the lake to supersede their expectations. I want them to wonder just like I do every time I see it, and then I want them to care.

—Todd Brennan, outreach coordinator at the Alliance for the Great Lakes, Milwaukee, Wisconsin

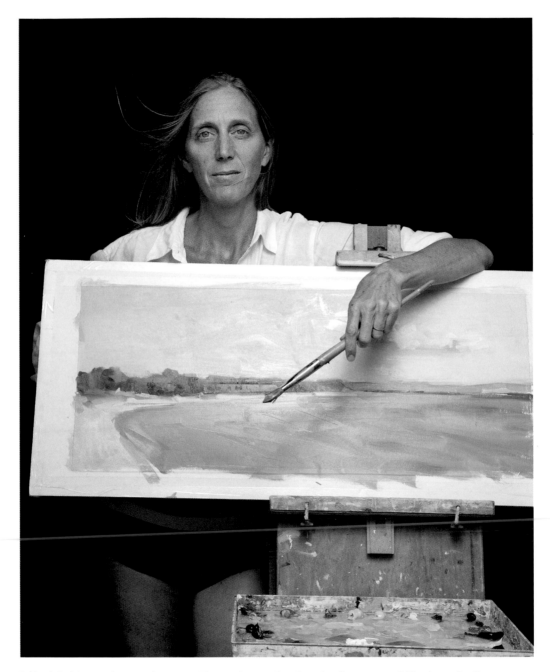

Lake Michigan always changes. The palette of colors in the water shifts from indigo to turquoise, pale orange to flat gray. Sometimes it's sky blue; sometimes it's almost white. The curl of the waves on a sunny day looks like luminous green grass. —Angela Saxon, painter, Maple City, Michigan

Visiting artists at Ox-Bow School for the Arts, Saugatuck, Michigan (opposite, clockwise from top left): Amanda Wong, Dan S. Wang, Vivian Kvitka, Kendall Babl

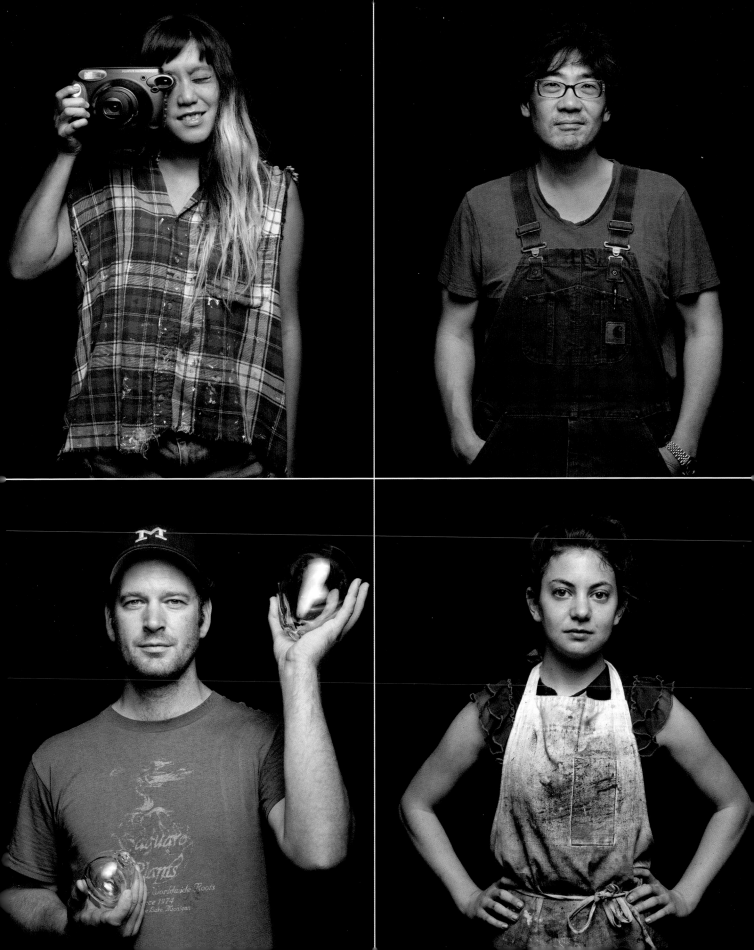

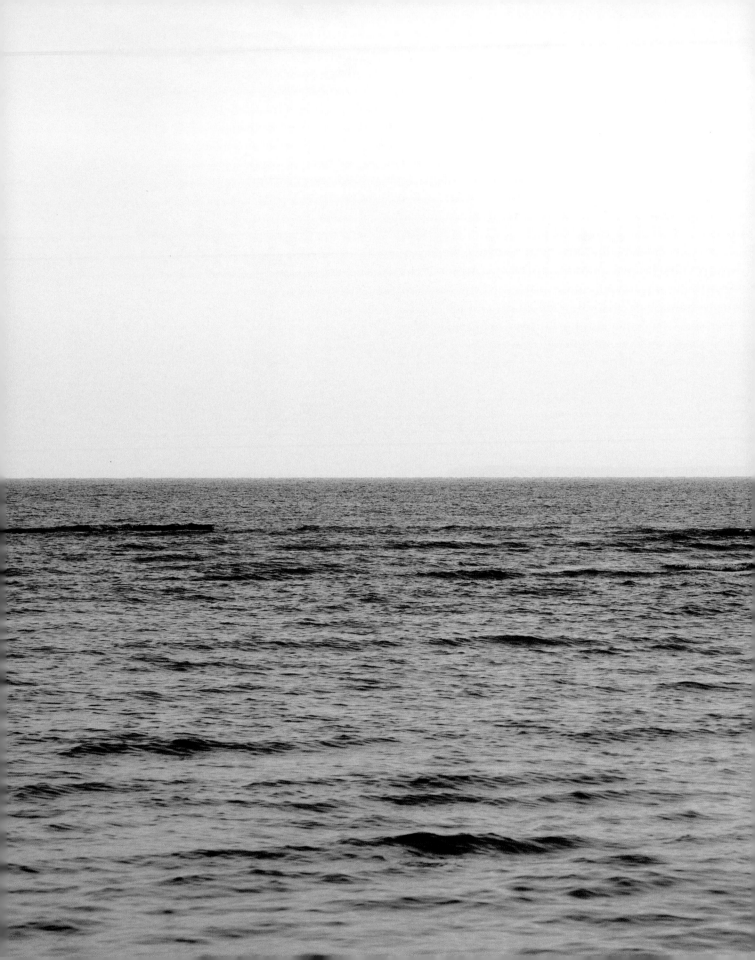

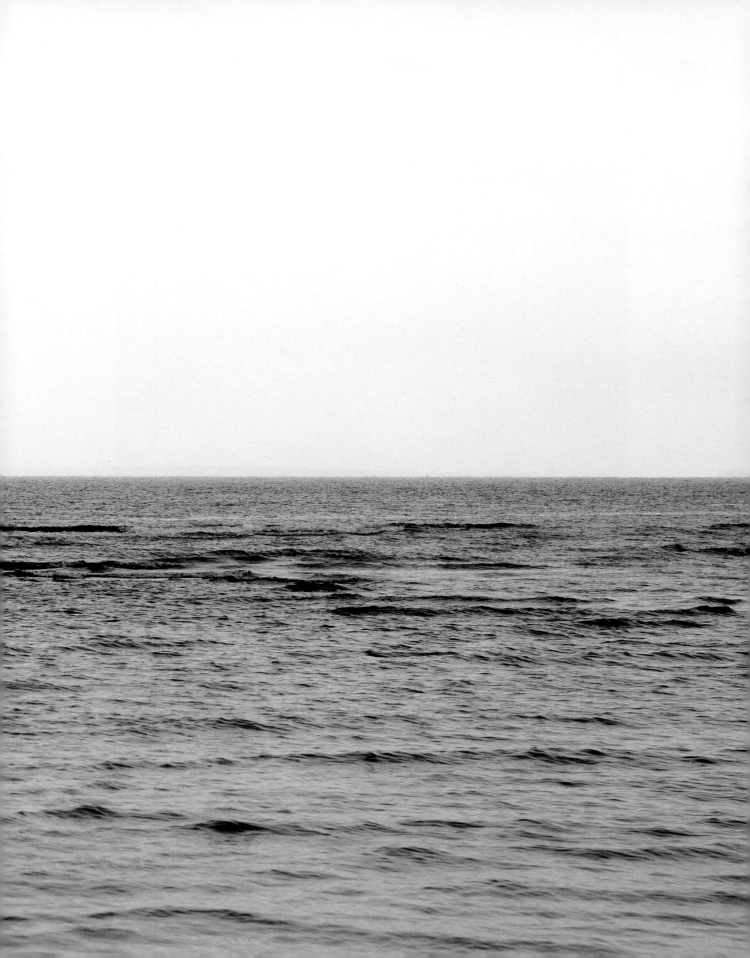

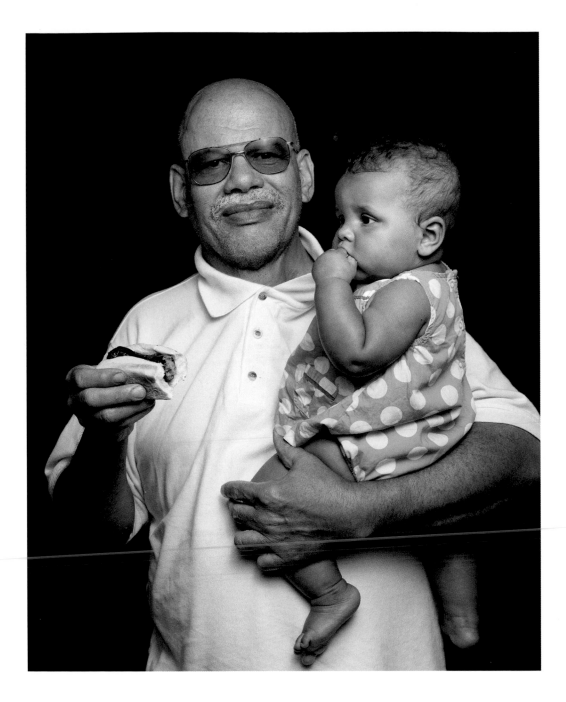

John Jones and his granddaughter Nessa (above), visitors to General King Park, Sheboygan, Wisconsin

David Baptista (opposite), visitor to Montrose Beach Park, Chicago, Illinois

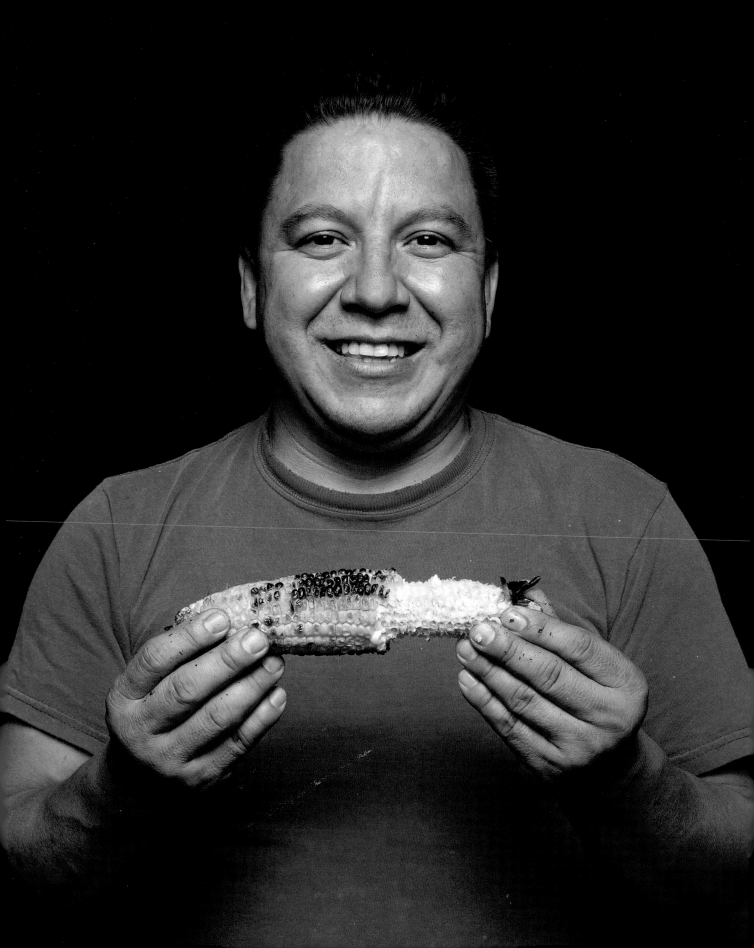

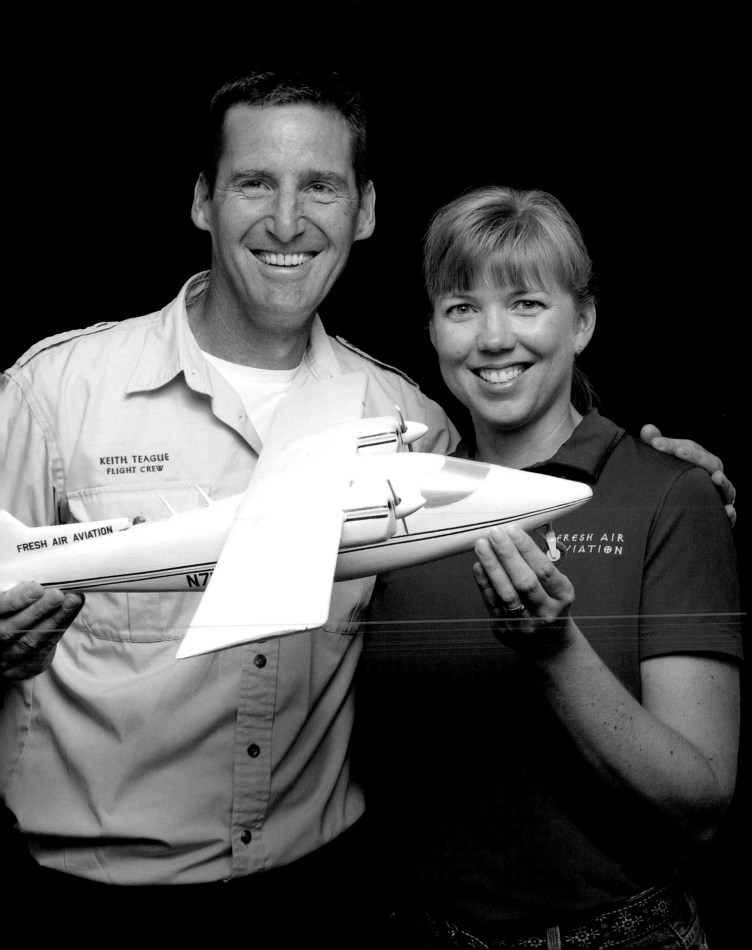

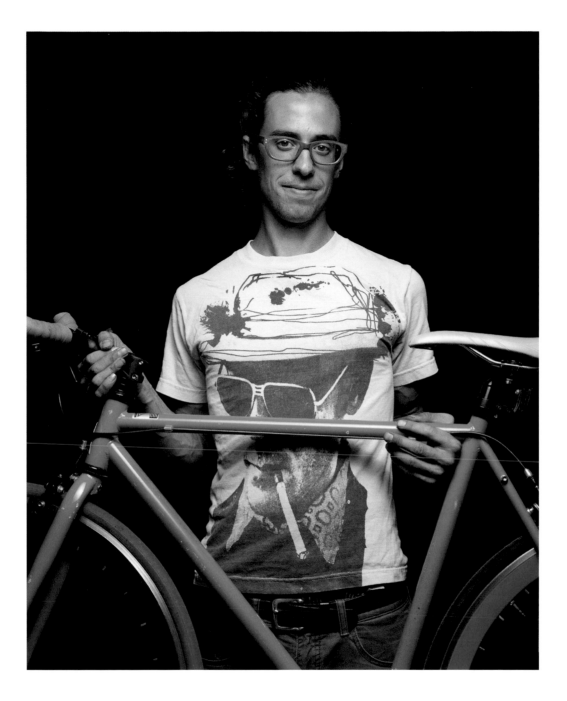

Keith and Rachel Teague (opposite), owners of Fresh Air Aviation, which flies daily over Lake Michigan to Beaver Island, Charlevoix, Michigan

Derek Kessler (above), visitor to Montrose Beach Park, Chicago, Illinois

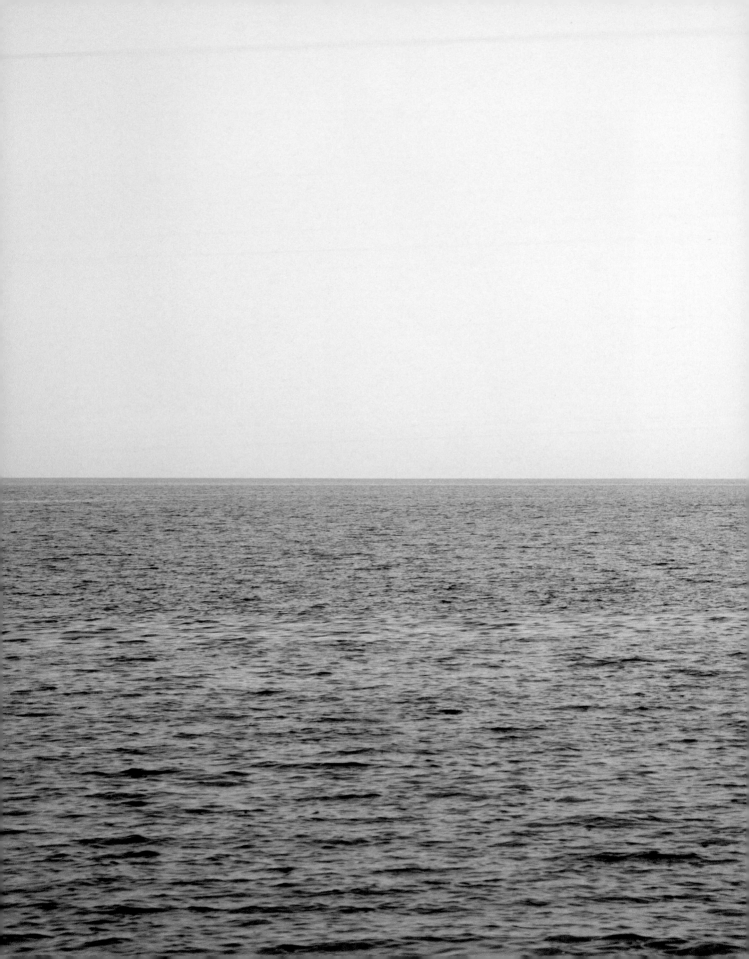

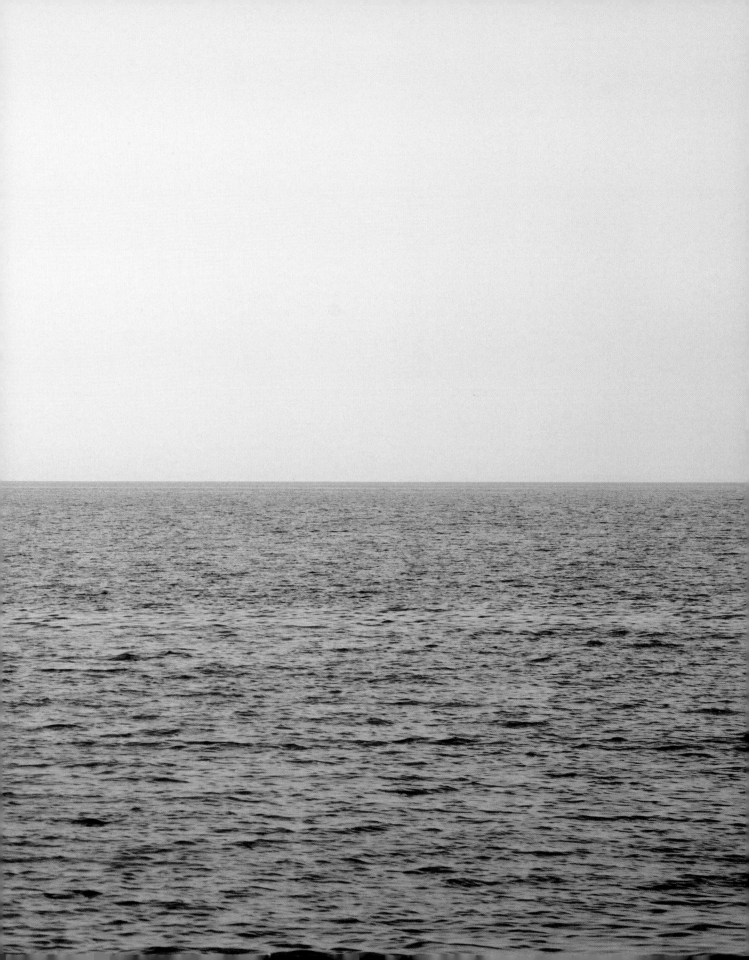

Having spent a few weeks of each summer on Lake Michigan since I was a baby, Lake Michigan has become a certain kind of home to me. It's a place where everything that causes me anxiety disappears and I can spend time with the one thing that matters most: family.

—Anna Filipic, right (quoted here), with mother Julie Filipic, left, and grand-mother Margee Ruggles, center, longtime vacationers to Elk Rapids, Michigan

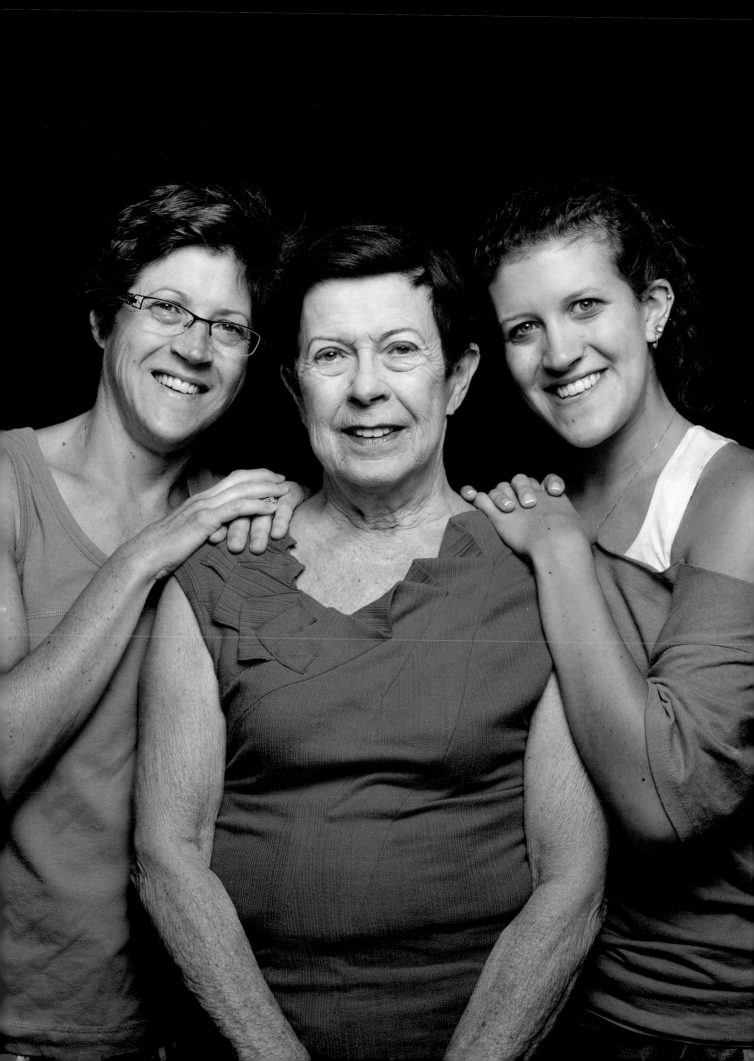

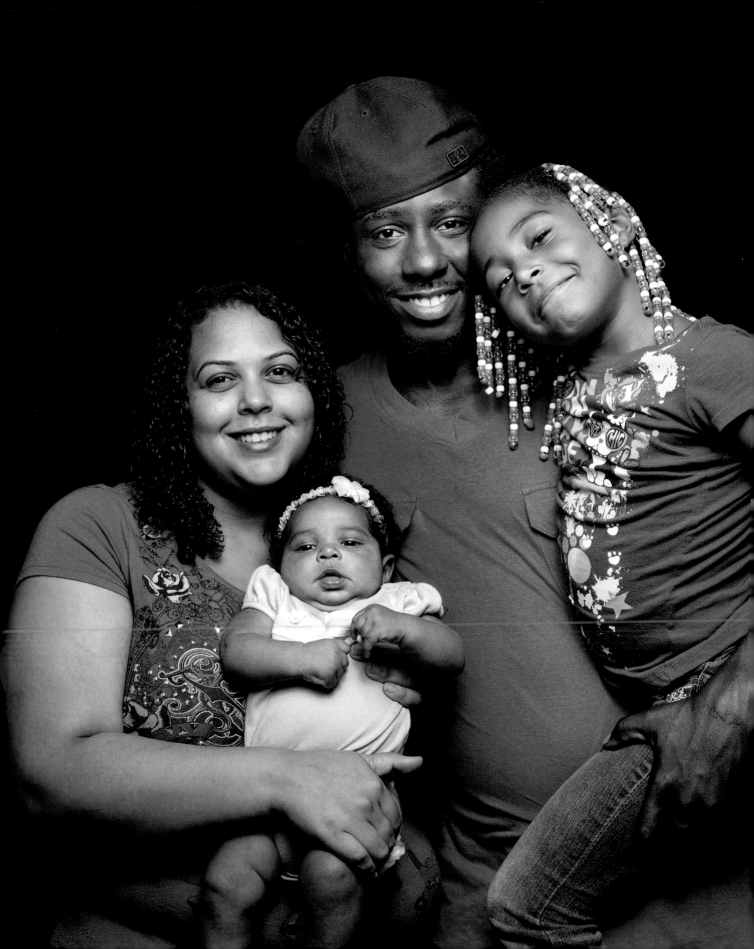

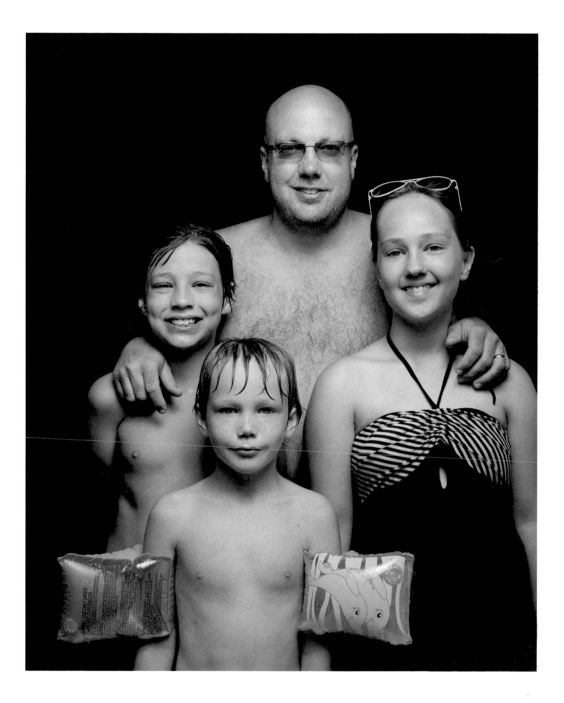

Valerie Diaz, Dino Rich, and their daughters (opposite), visitors to General King Park, Sheboygan, Wisconsin

Michael Vick and his family (above), visitors to Holland State Park, Holland, Michigan

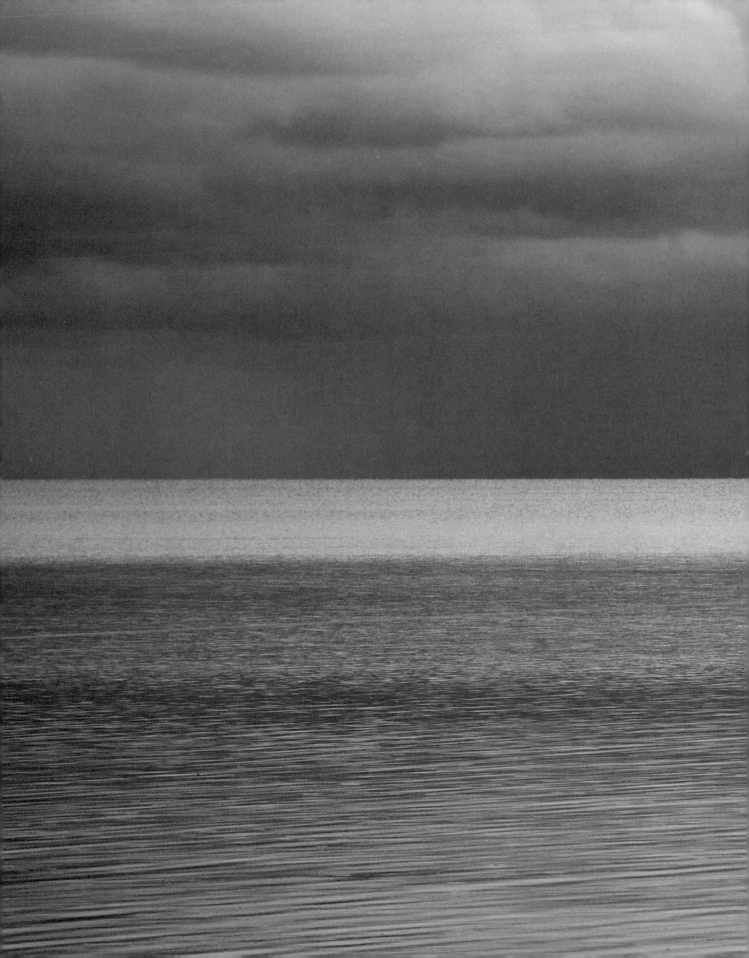

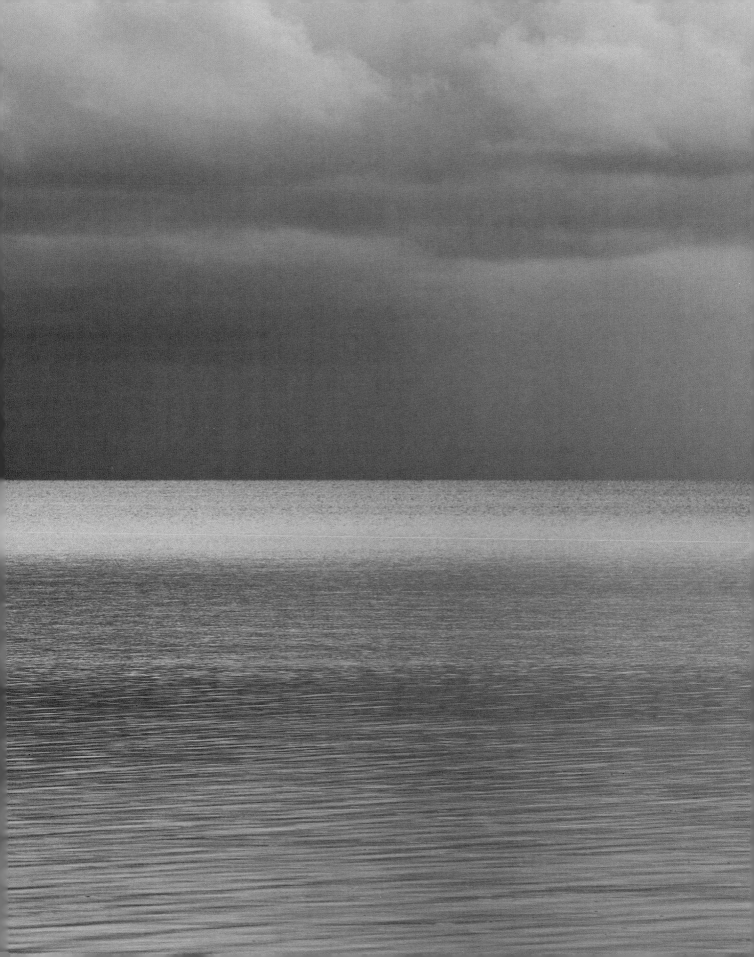

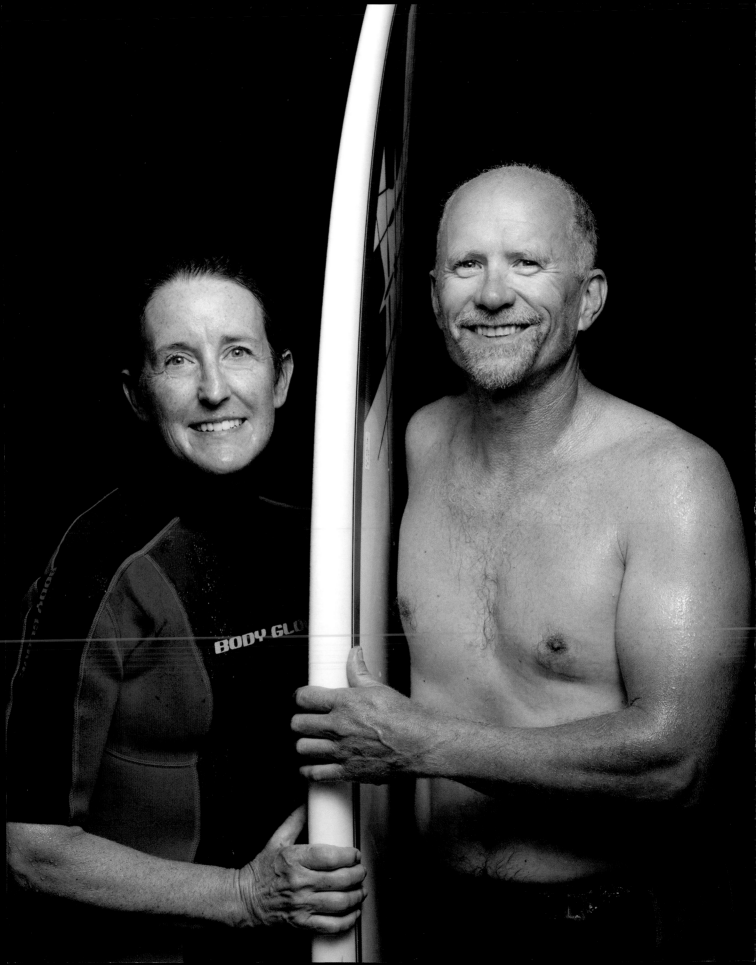

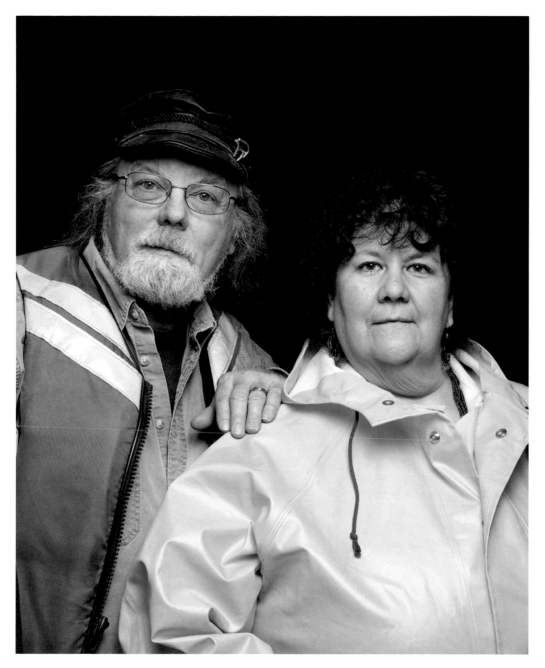

Lake Michigan's beauty lies mostly beneath the skin, below the surface. Like our own bodies, blemishes come and go, but it is care of the whole that provides long life. —Russell Cuhel (quoted here) and Carmen Aguilar, scientists at the UW–Milwaukee School of Freshwater Sciences, Milwaukee, Wisconsin

Nancy and Larry Bordine (opposite), surf shop owners, Frankfort, Michigan

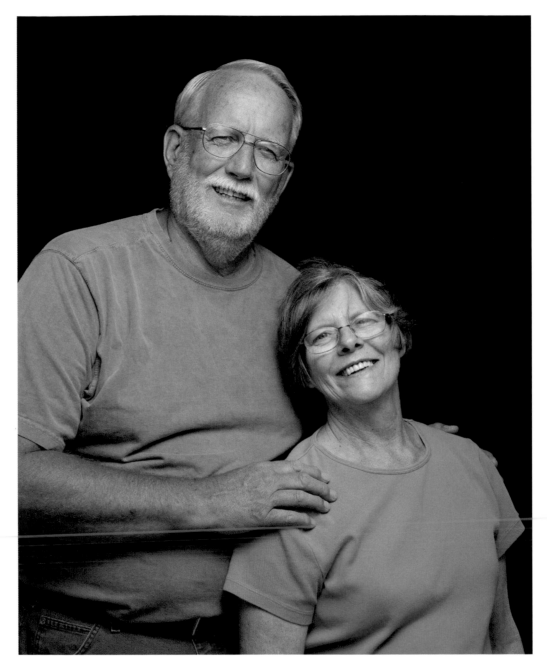

Just keeping it like it is for those coming along after us to walk along and enjoy like we have. I think this can be one of the greatest gifts those of my generation could leave for those walking in our footsteps years from now. —John (quoted here) and Eunice Walker, who walk daily along the shoreline, Manistique, Michigan

Ibrahim Bedaso and Toltu Tufa (opposite), visitors to Montrose Beach Park, Chicago, Illinois

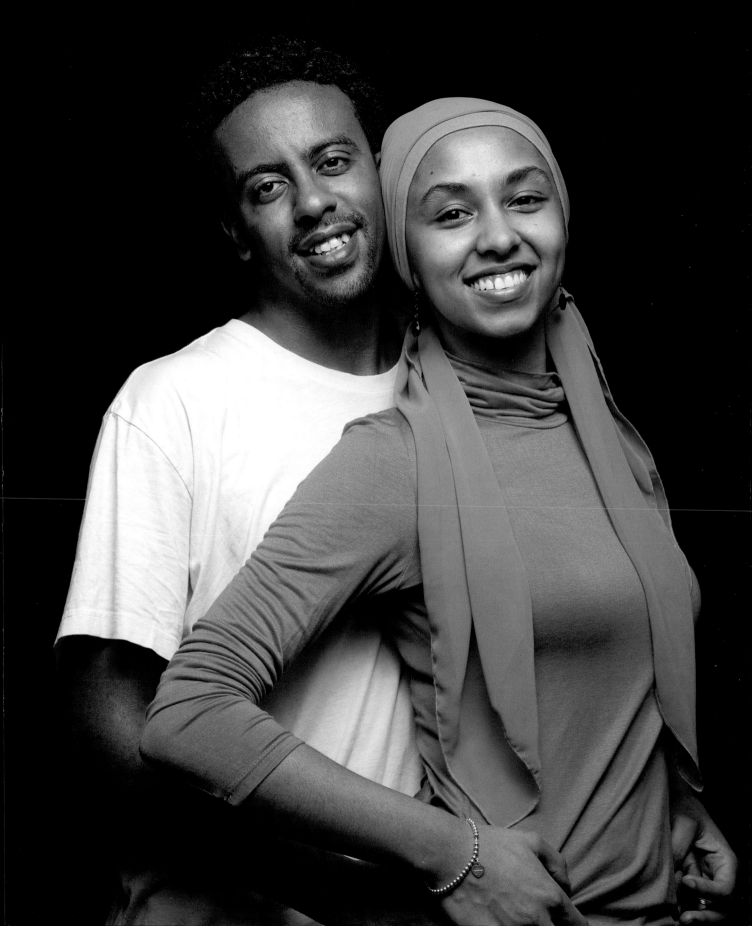

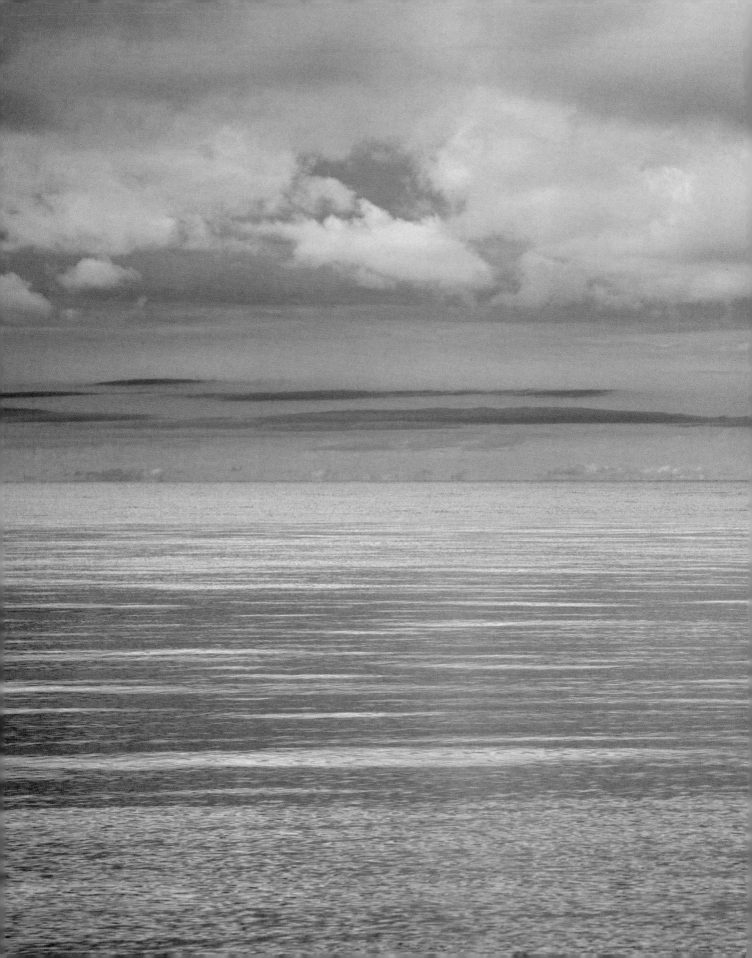

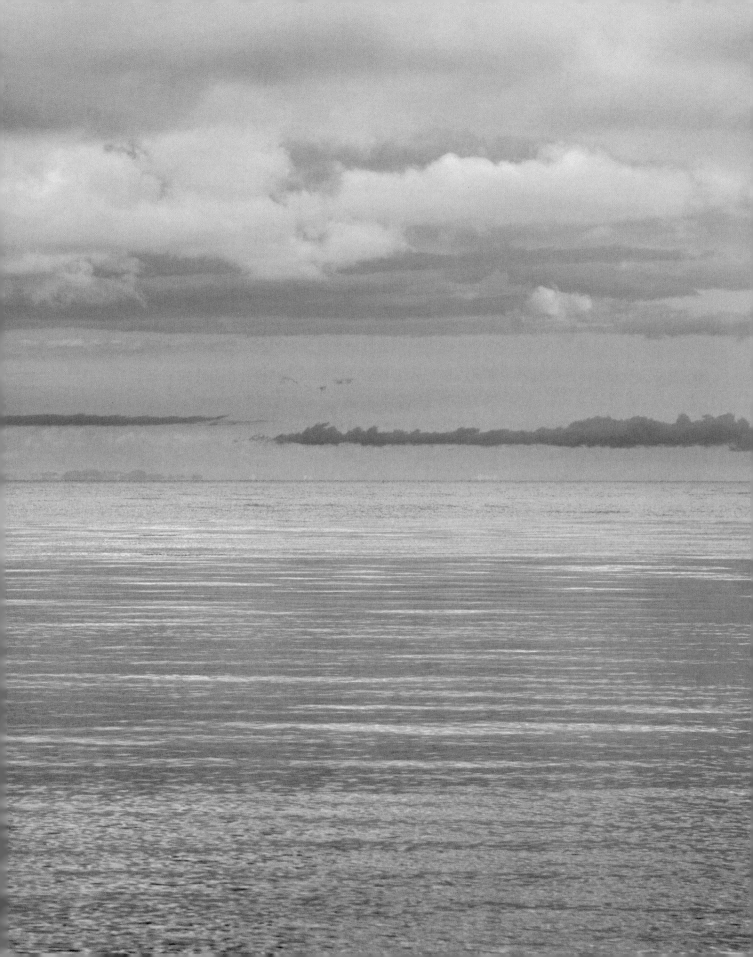

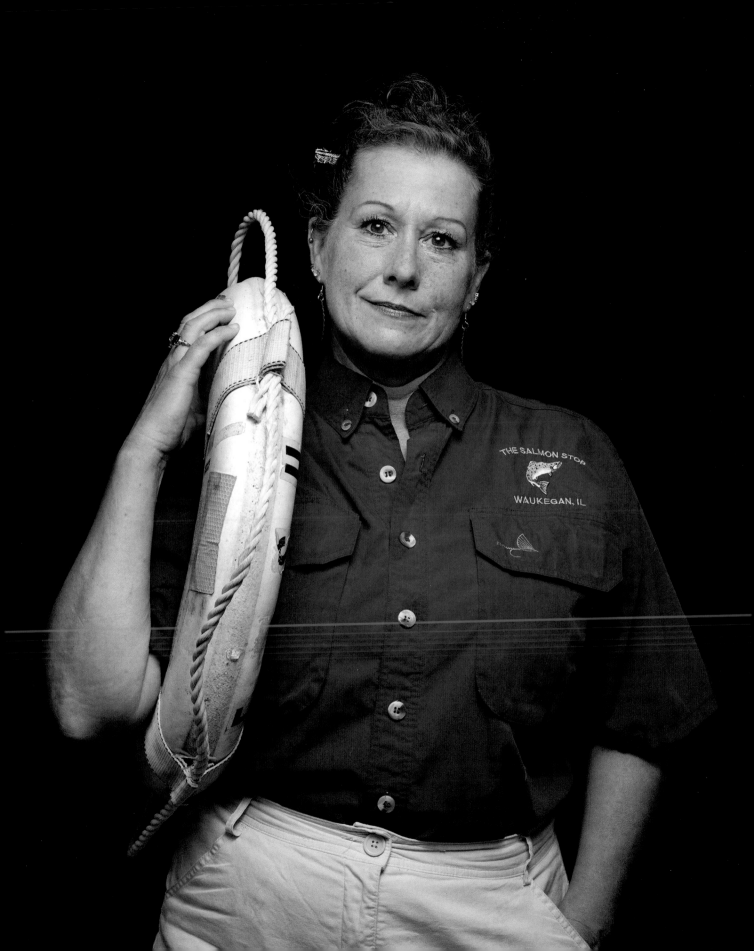

I look out my living room "picture frame" window and every morning the sunrise is always different—like snowflakes, no two are alike. The peacefulness of sitting on my porch or out on the boat looking at the water and the beautiful sky . . . I kinda forget all the bad going on in the world and thank God for this beautiful lake he has blessed us with.

—Lori Ralph, second-generation bait and tackle shop owner, Waukegan, Illinois

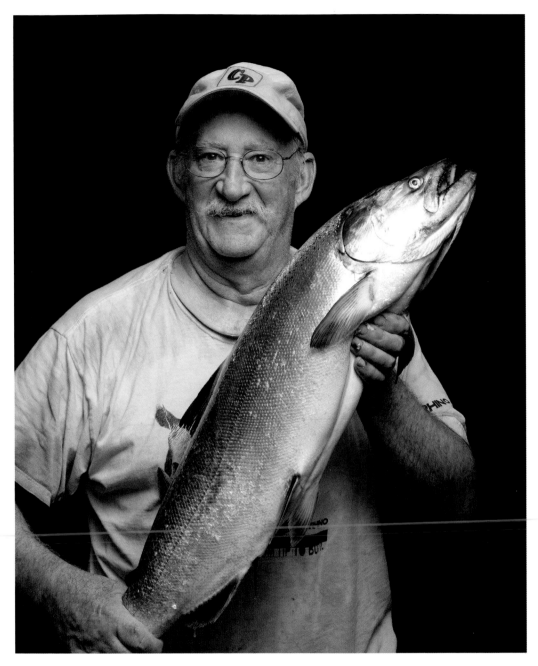

I was born and raised in the Chicago area. I drank the water from Lake Michigan most of my life. The Great Lakes water system is a wonderful piece of nature. To be able to drink the water and eat the fish in this day and age is a great event. —Mike Stewart, sportfisherman, Fairport, Michigan

Houa Khang (opposite), shore fisherwoman, Milwaukee, Wisconsin

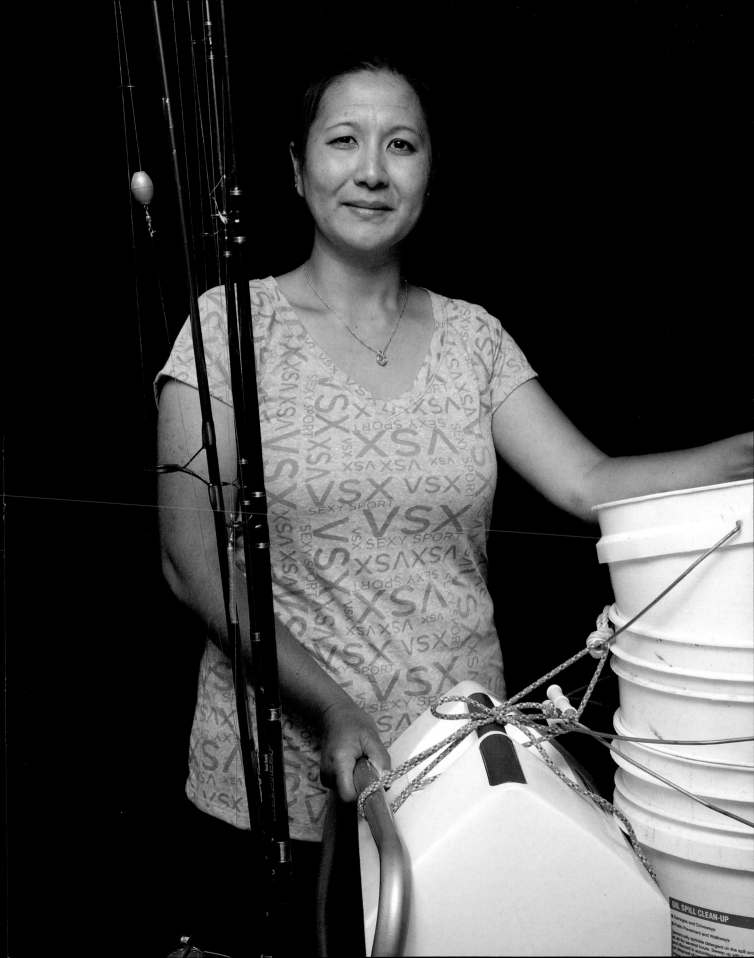

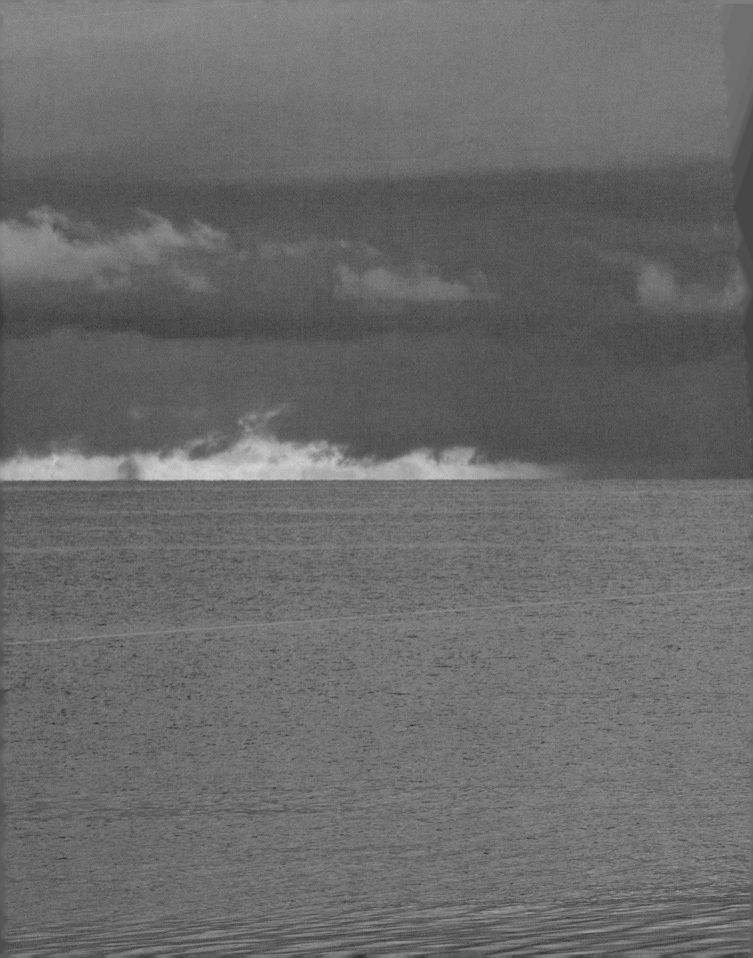

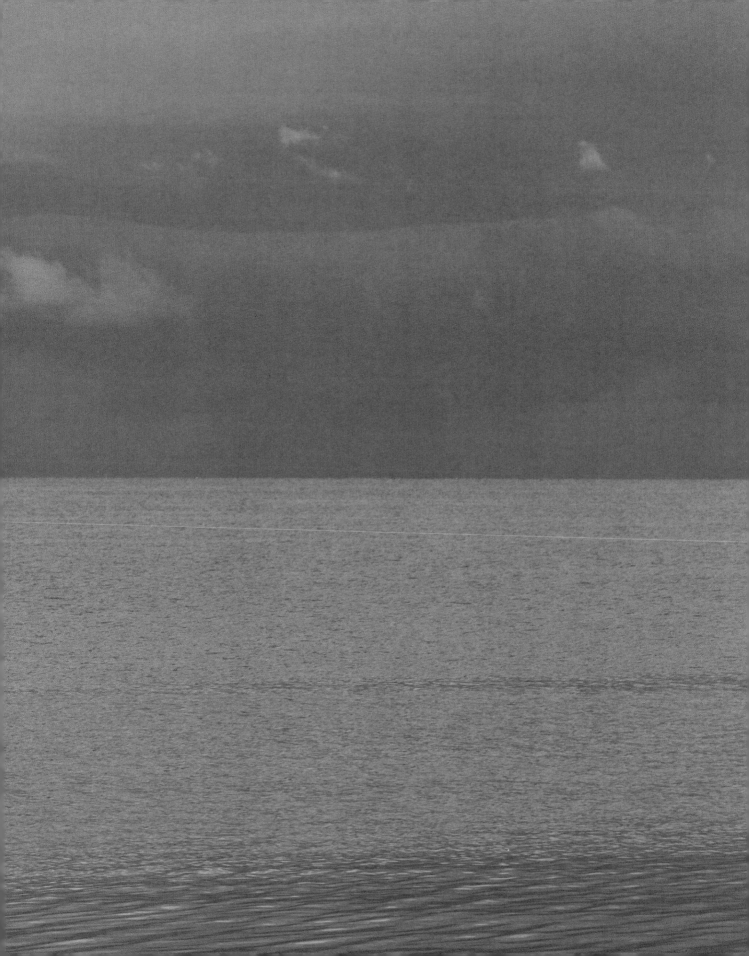

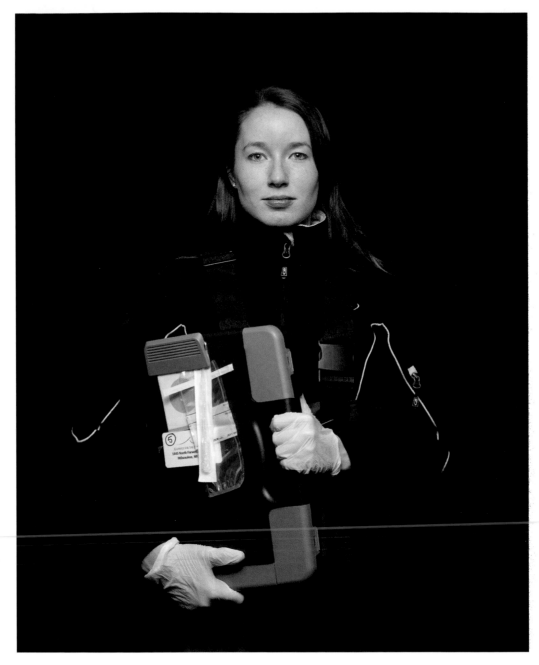

I frequently run along the shore or sit on the beach and do homework or read. I spend most of my summer in the water or watching other people enjoy the beach as well. I grew up with Lake Michigan in my backyard. It is very much part of who I am and what I love. —Caitlin Haberman, college student studying biological and environmental sciences and volunteer for Alliance for the Great Lakes, Milwaukee, Wisconsin

Ryan Bigelow and his daughter Kirra (opposite), visitors to Big Bay Park, Whitefish Bay, Wisconsin

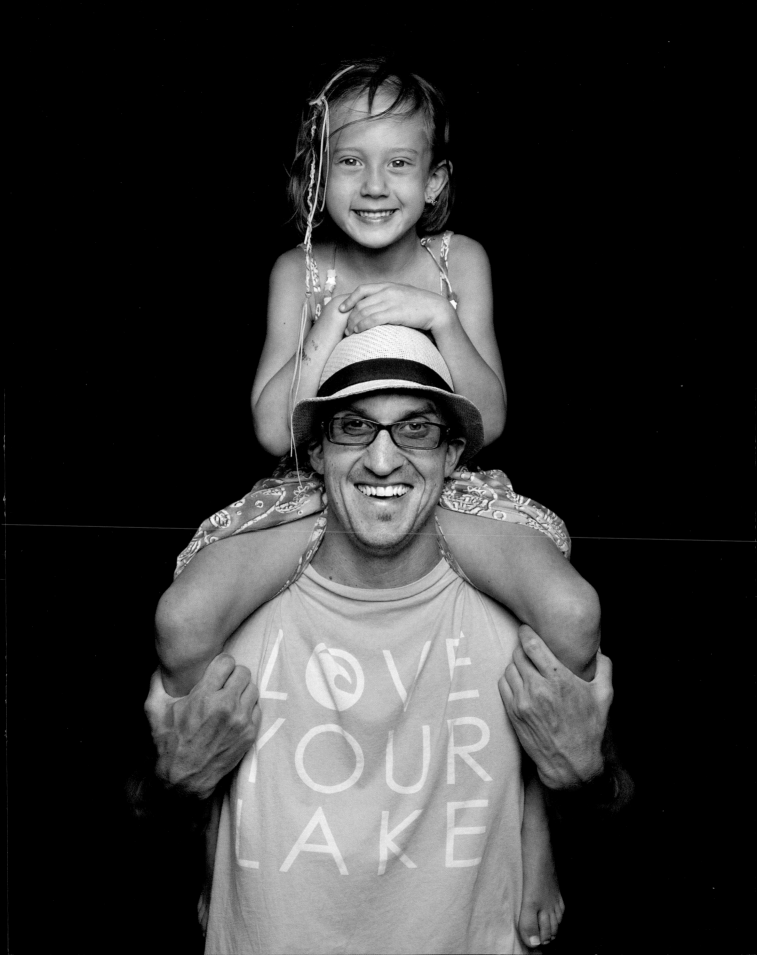

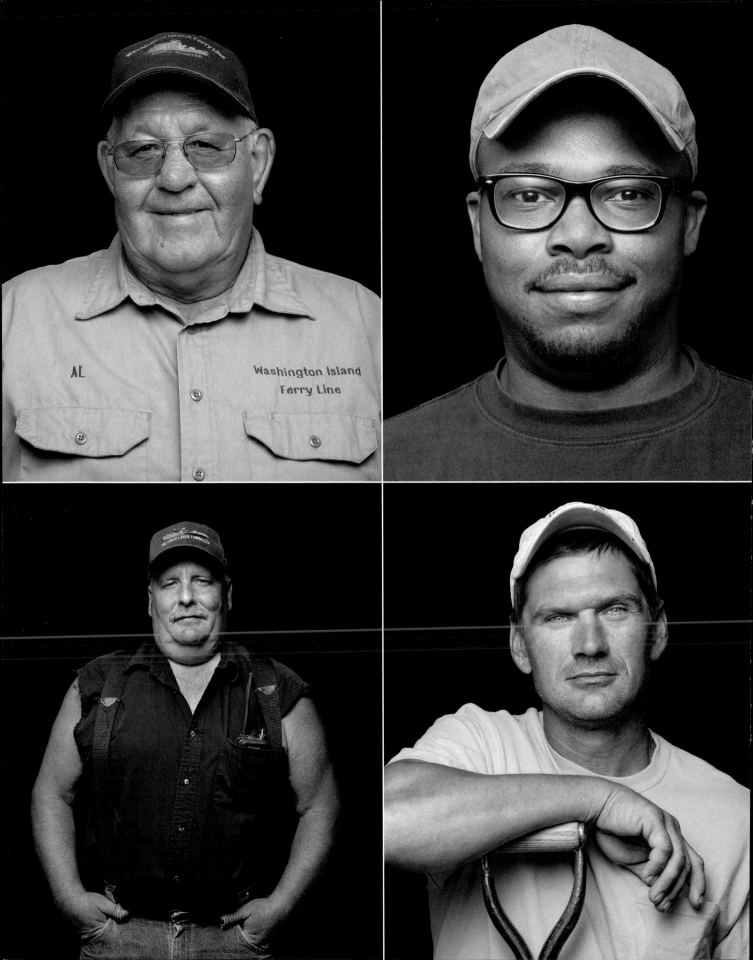

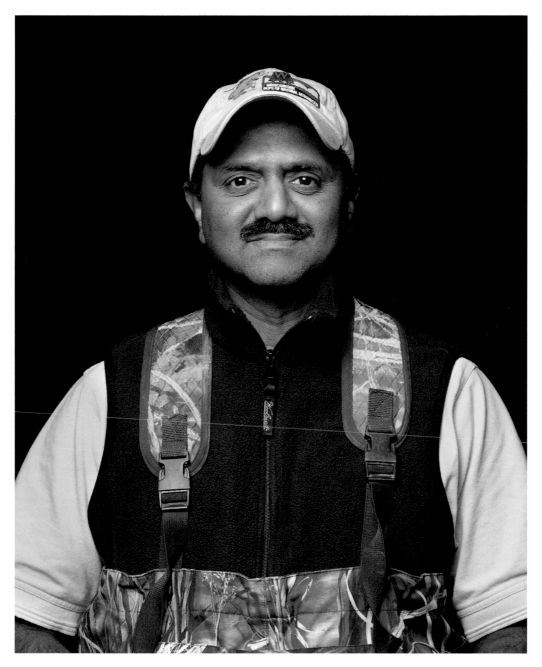

I studied so much about the Great Lakes while doing my graduate school in India and in the US. Now that I have the opportunity to be a part in managing this vast resource, I feel immensely responsible and honored. —Pradeep Hirethota, senior fisheries biologist, Wisconsin Department of Natural Resources, Milwaukee, Wisconsin

Opposite, clockwise from top left: Al Stelter, ferry worker, Washington Island, Wisconsin; Joshua Hampton, steelworker, East Chicago, Indiana; Dave Seidl, third-generation family farmer with land on Lake Michigan, Two Rivers, Wisconsin; Chip Walsh, tugboat captain, Milwaukee, Wisconsin

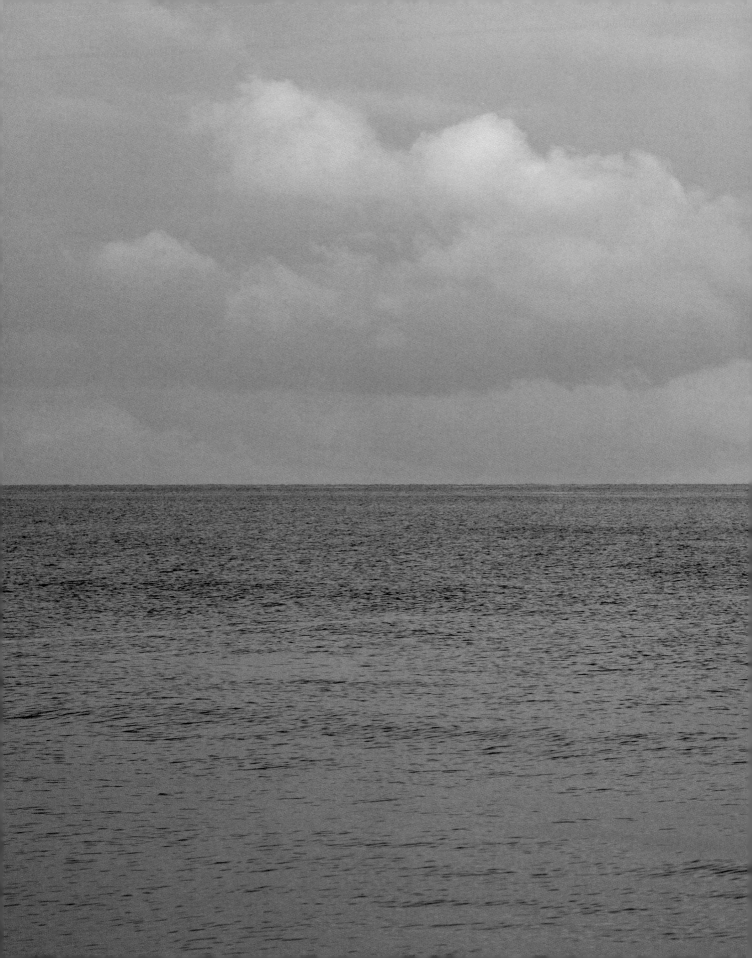

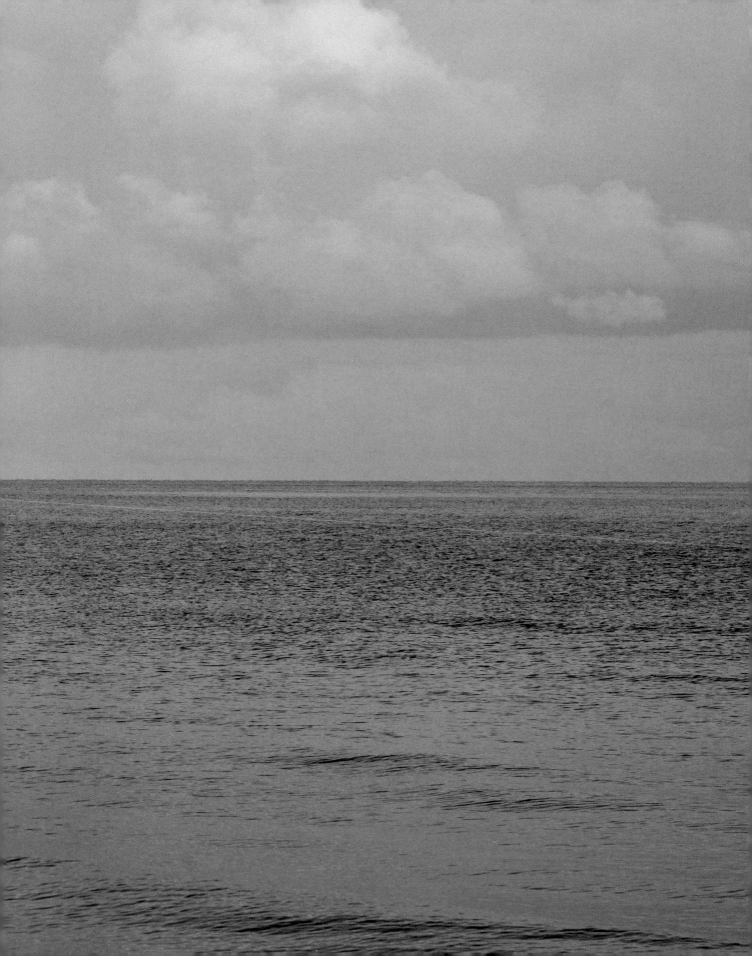

I've grown up in Beverly Shores, Indiana, right on the shores of Lake Michigan. I would spend every day in the summer on the beach but also enjoyed seeing her change throughout the seasons, when most people don't think of going to the lake. I've always felt a sense of calm and a feeling of being at home while on Lake Michigan. It was the place I would go to relax, to have fun, to clear my mind. It's my safe place.

—Amy Lukas (quoted here) and Mary Catterlin, canoeists from Beverly Shores, Indiana, who paddled a homemade dugout canoe around the perimeter of Lake Michigan, Sevastopol, Wisconsin

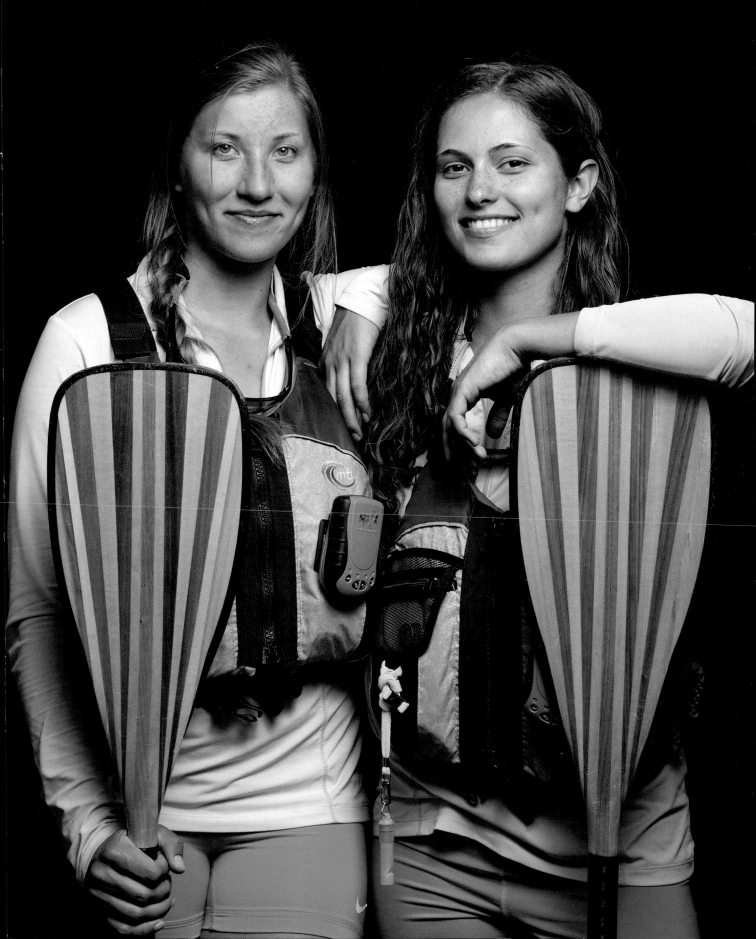

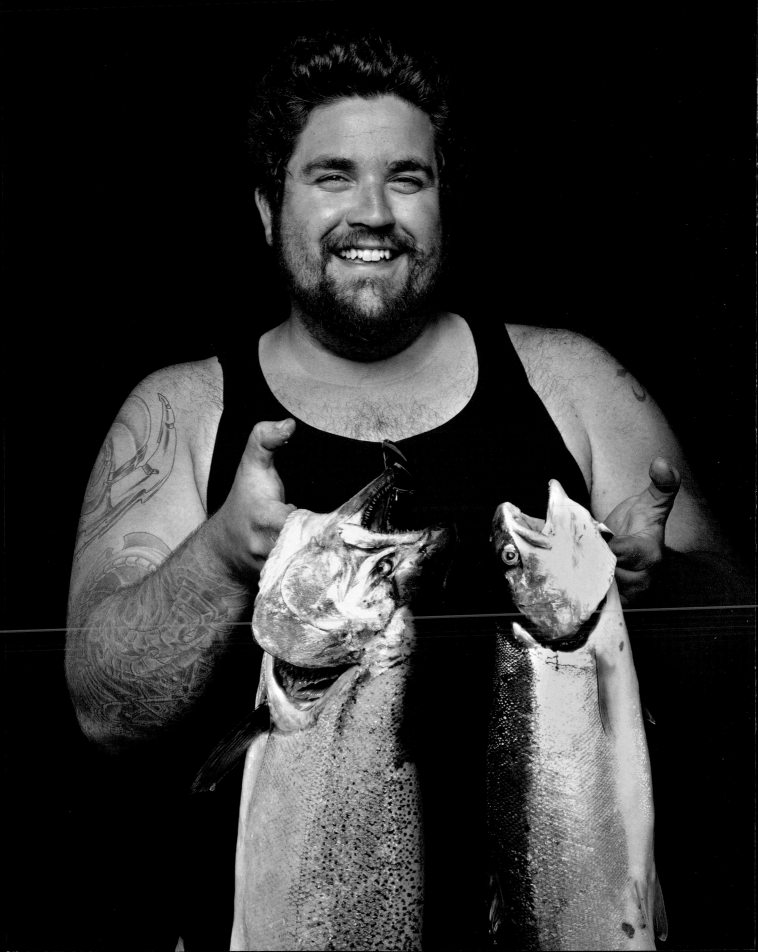

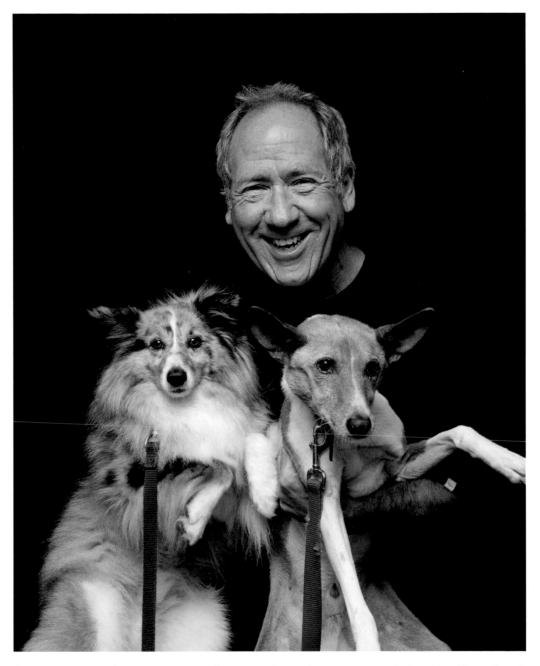

As a young man, the vast expanse of water, as far as the eye can see, helped heal heartbreak and calm panic. In my sixties now, I remain grateful. The lake is part of me. —John Schneider, actor and writer (and Wriggly and Harlen), Milwaukee, Wisconsin

Scott Jackson (opposite), sportfisherman, Milwaukee, Wisconsin

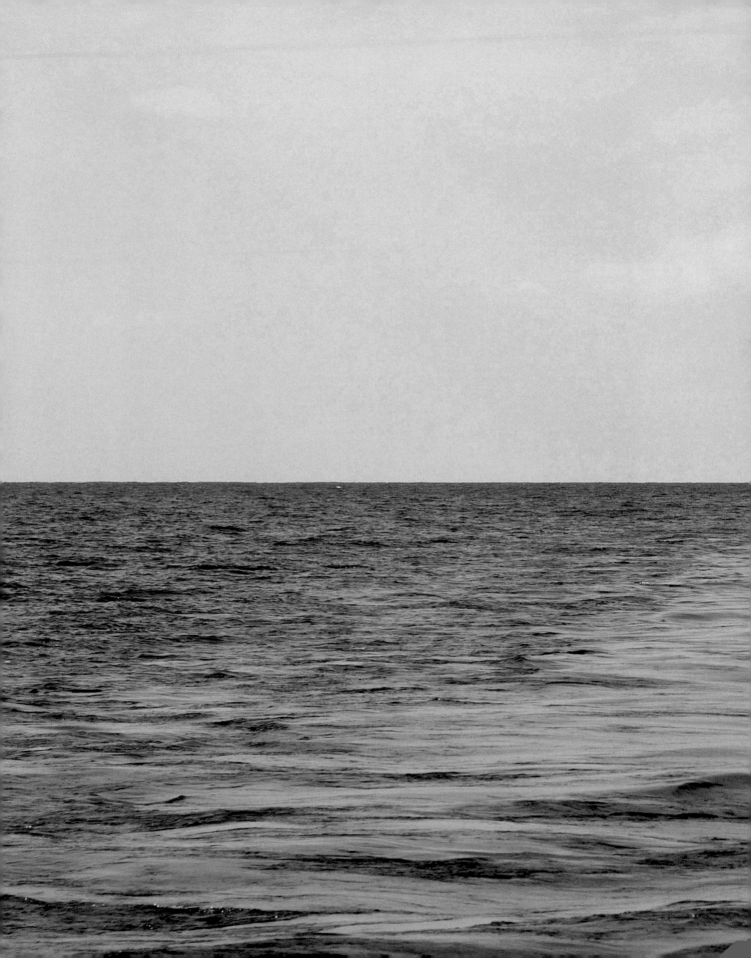

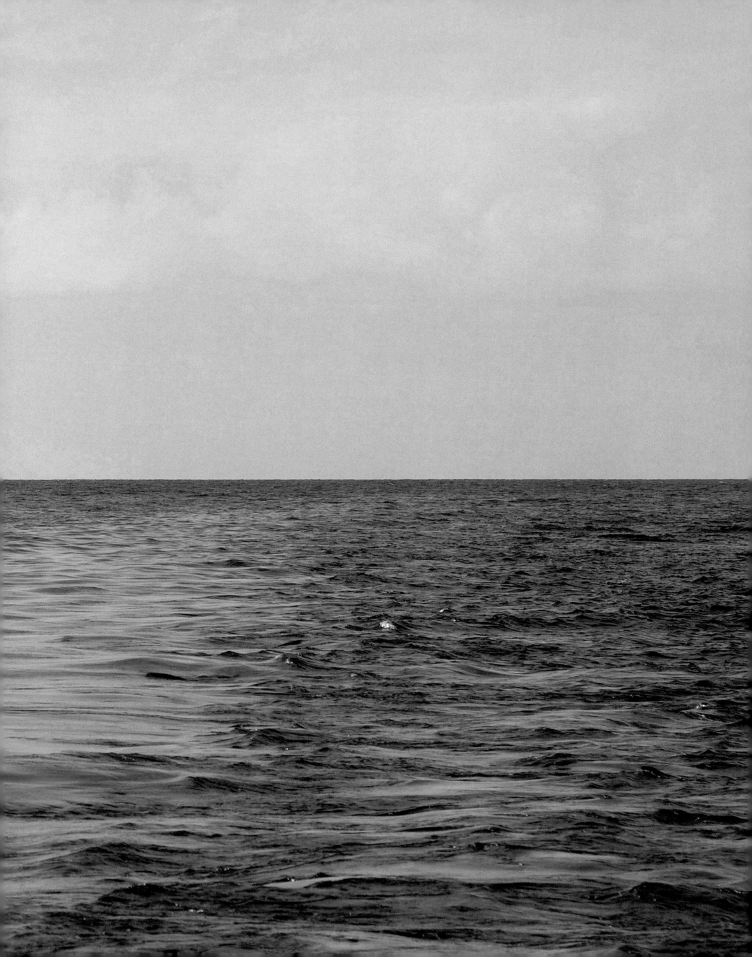

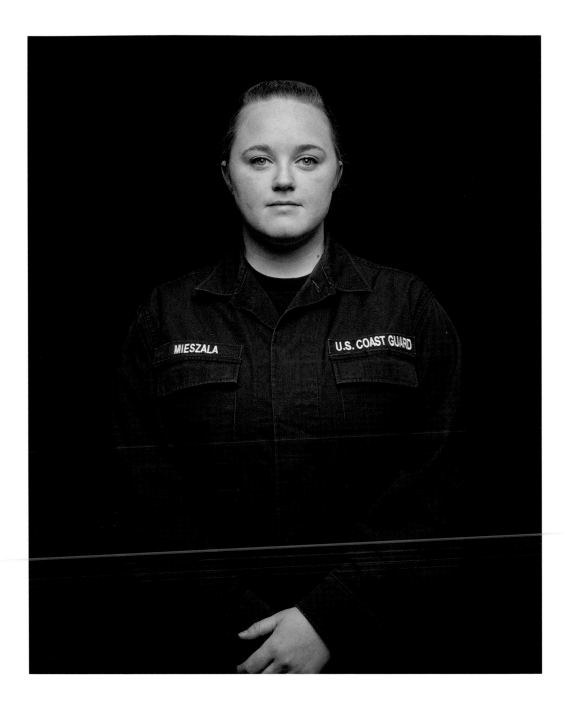

US Coast Guard members, Kenosha, Wisconsin: Jasmine Mieszala (above), fireman, and (opposite, clockwise from top left) Boatswain's Mate 2nd Class Eugene Conlon II, Seaman Yolanda Rodriguez, Seaman Darci Hickey, Electrician's Mate 2nd Class Stephen Hardison

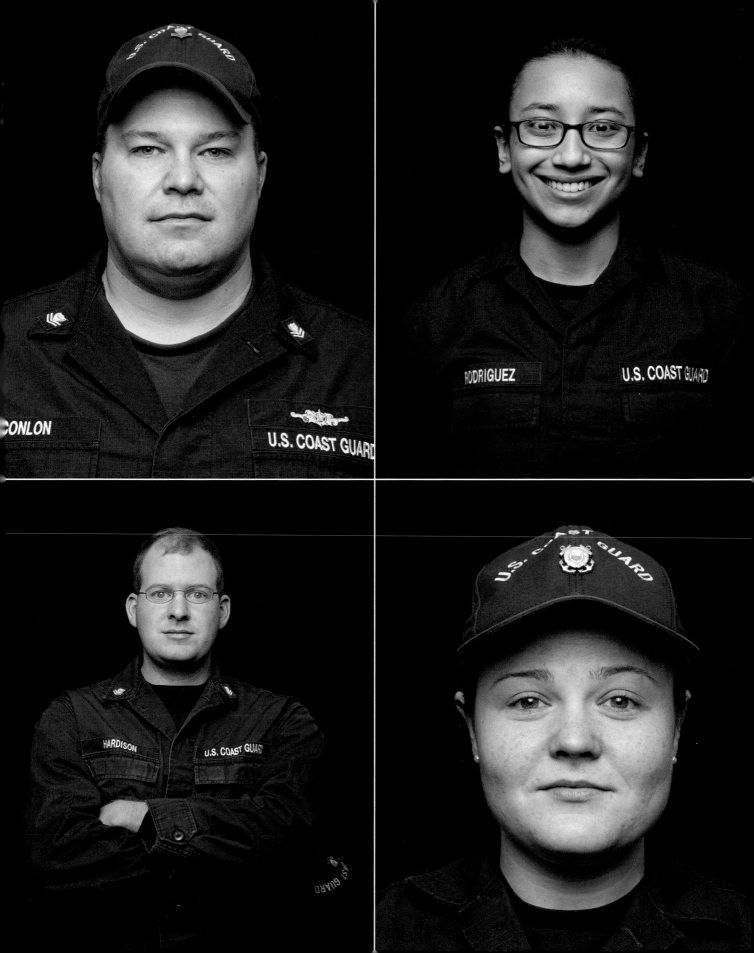

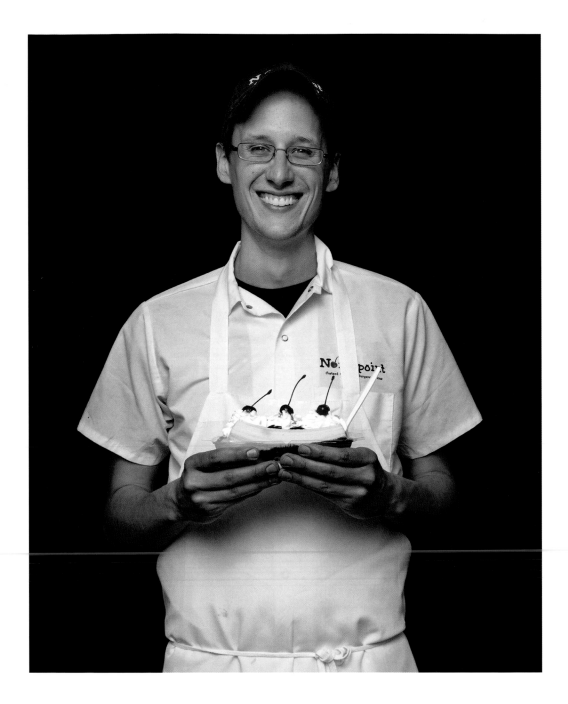

Timothy Braatz (above), worker at Northpoint custard stand, Milwaukee, Wisconsin

Annalise Povolo and Flannery Johnson (opposite), workers at Carlson's Fishery, Fishtown, Leland, Michigan

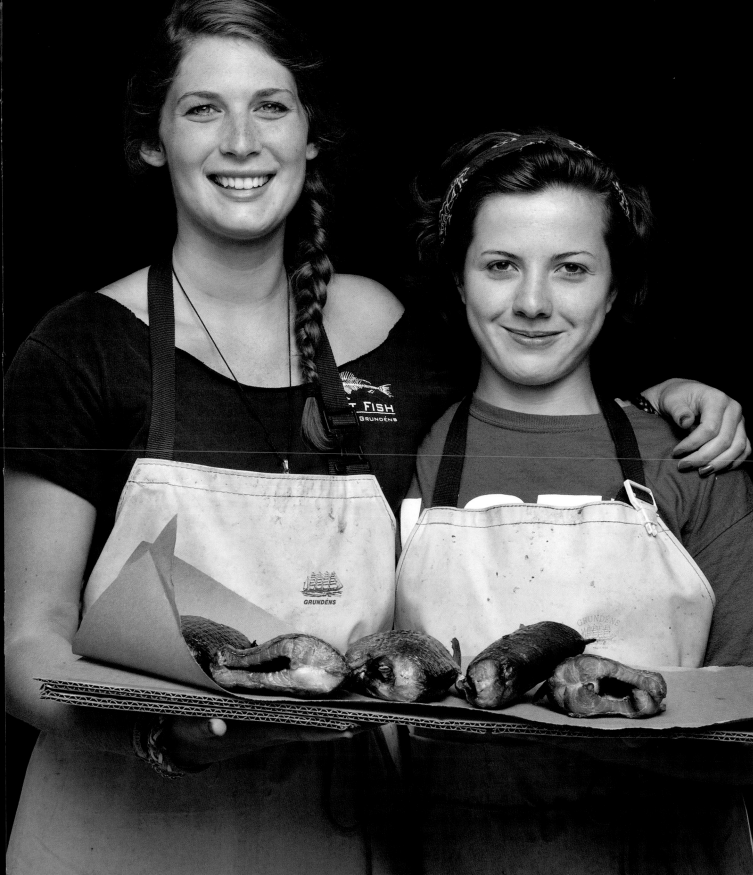

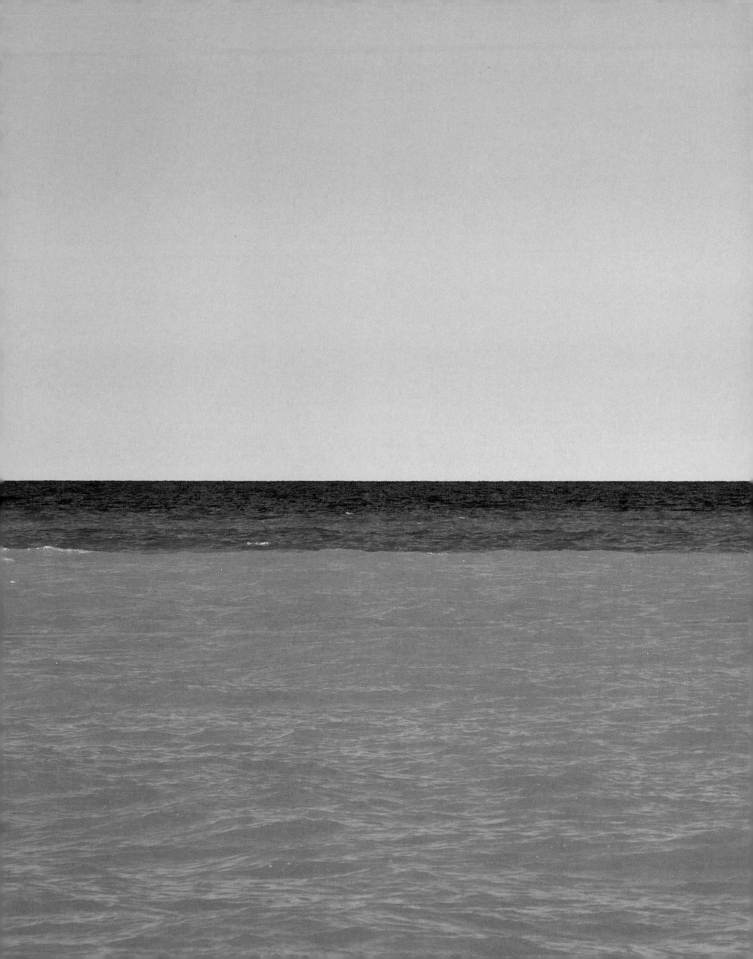

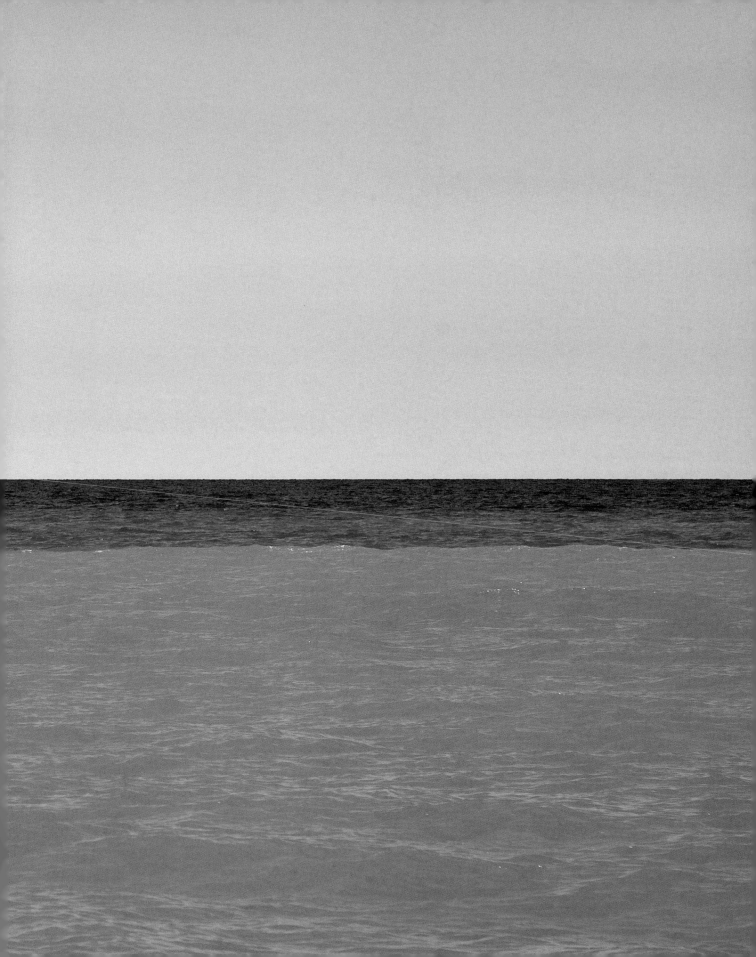

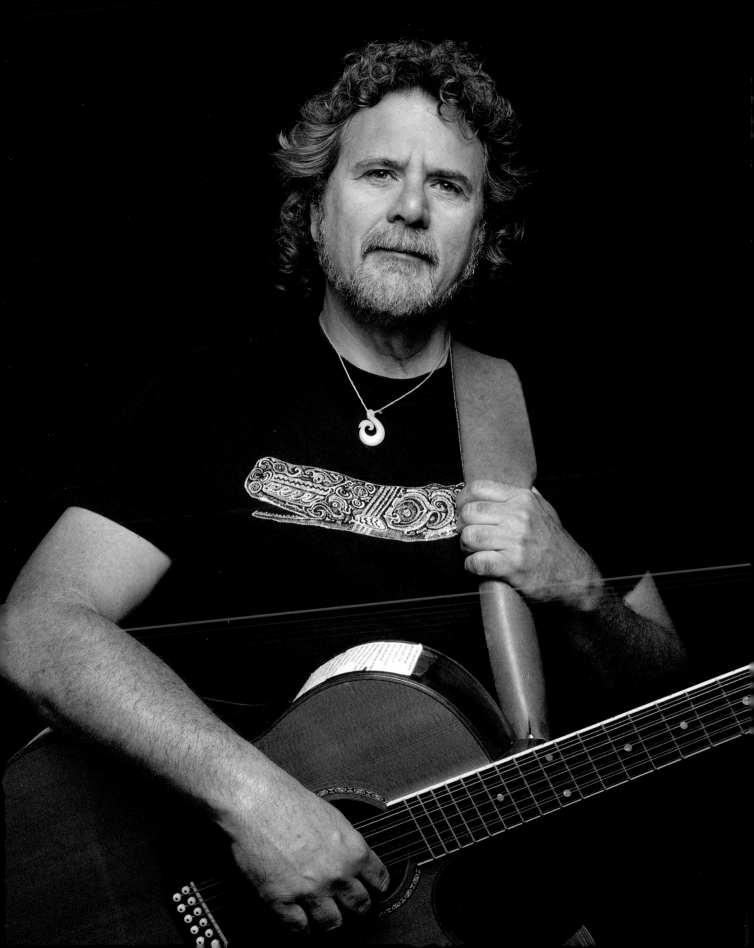

The Great Lakes are 20 percent of all the surface fresh-water in the world. Lake Michigan itself is large enough to put all of England inside it—and it is only the third largest Great Lake! Tourists in Chicago frequently call the lake "the ocean" because, to them, a lake so large as not to see the other side is incomprehensible. They are a hardy but, at the same time, vulnerable ecosystem.

—Tom Kastle, captain, maritime musician, and codirector of the Chicago Maritime Festival, Port Washington, Wisconsin

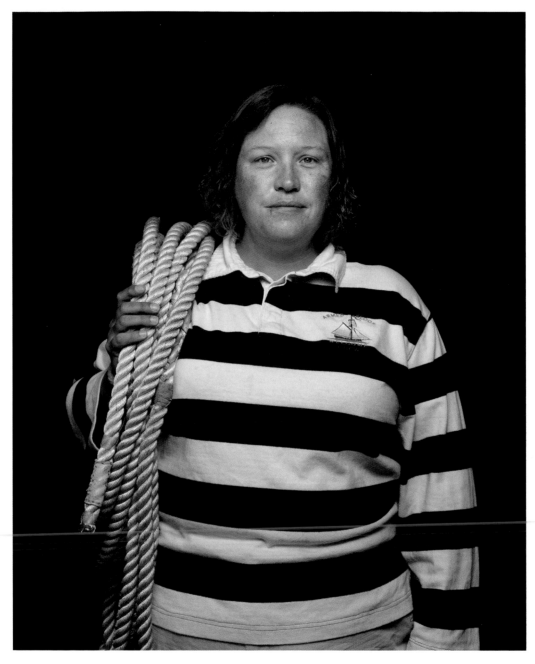

Lake Michigan has brought me some of the most inspiring moments of my life. It has pushed me to go further, to do more, and to be more than I ever thought I was capable of. It is vitally important to me that the lake be preserved for future generations. —Theresa O'Byrne, crew member of the schooner *Madeline*, Port Washington, Wisconsin

Rich Kuenstler (opposite), crew member of the schooner *Denis Sullivan*, Port Washington, Wisconsin

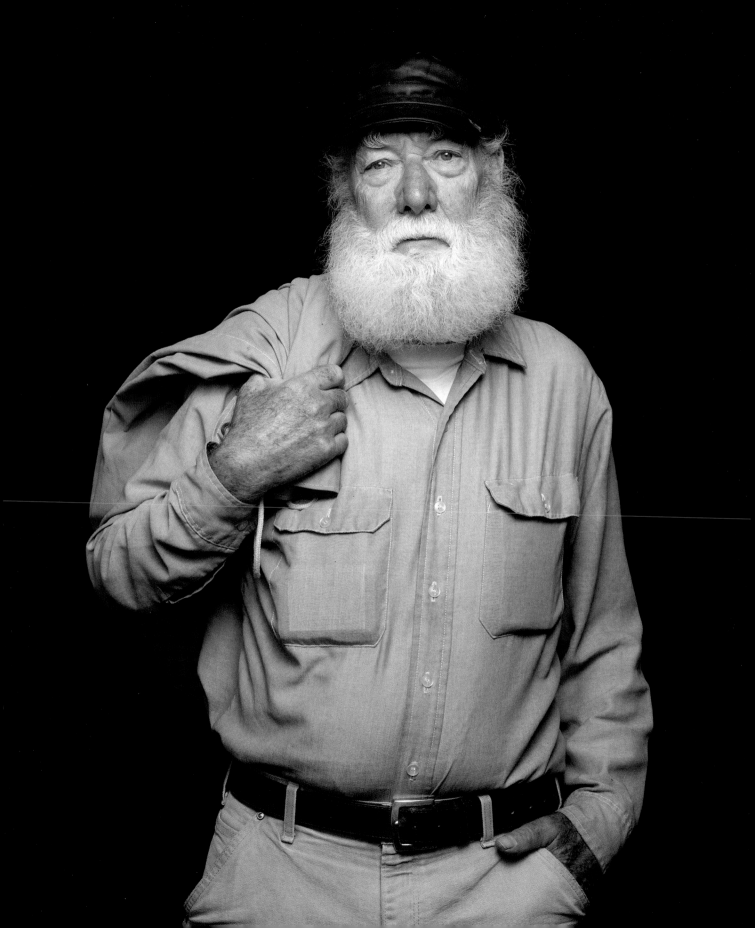

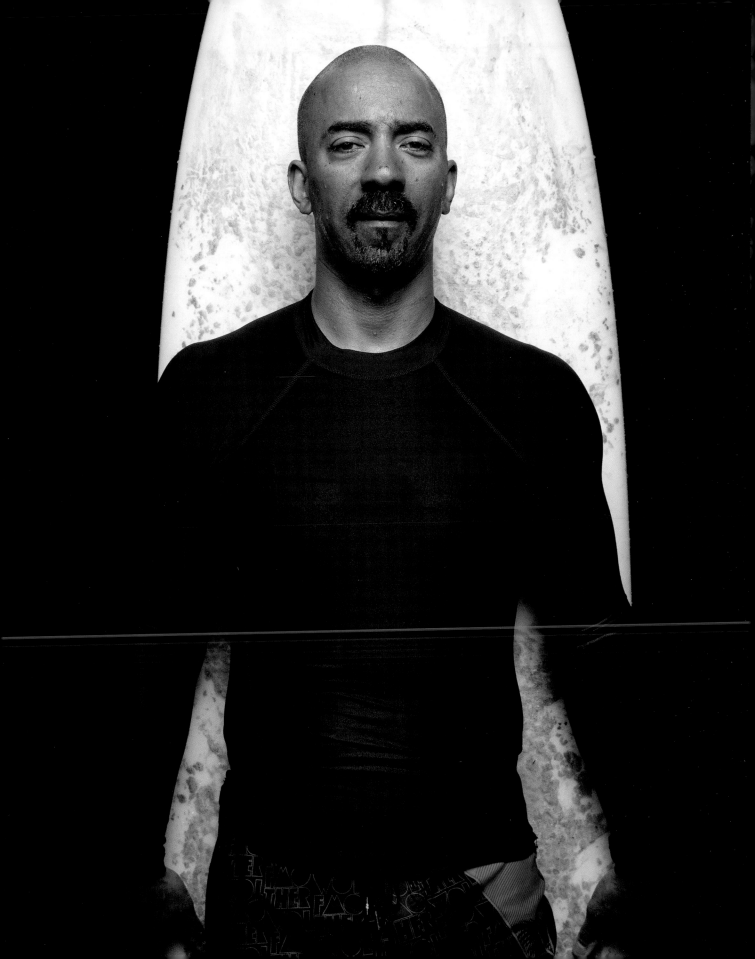

I'm drawn to the lake as it is the great equalizer and accessible to all. To me, it is meditative and exhilarating, a place of warmth, or a refreshing, yet frigid, dose of reality. Calming and challenging. At civil twilight or at sunset, it always reassures, refreshes, and reminds me of my place in this world. And for that I am appreciative, honoring, and continue to protect and give deference to it.

—Kenneth Cole, surfer, Big Bay Park, Whitefish Bay, Wisconsin

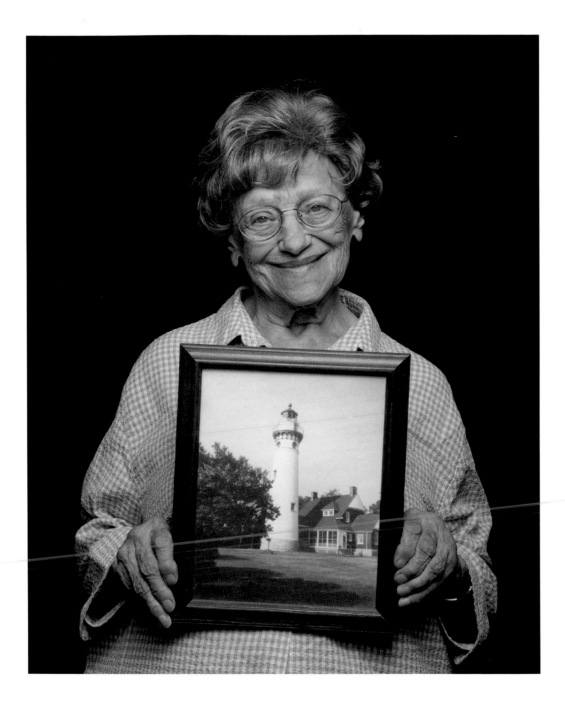

Naomi Sanders (above), volunteer for the Seul Choix Point Lighthouse, Gulliver, Michigan

Davis Chang (opposite), visitor to General King Park, Sheboygan, Wisconsin

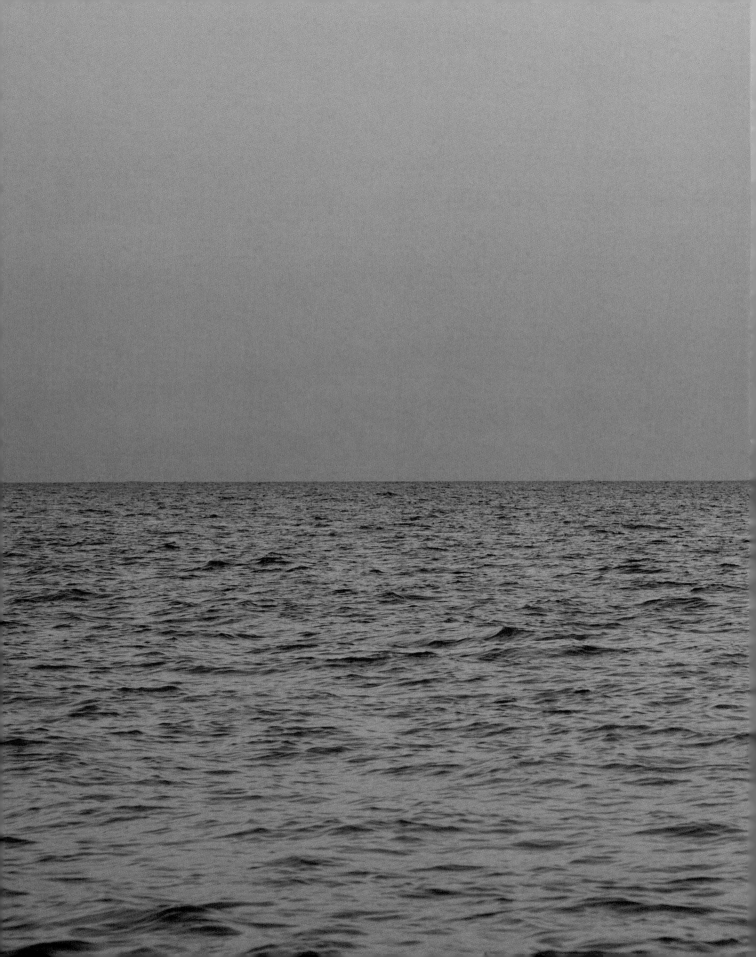

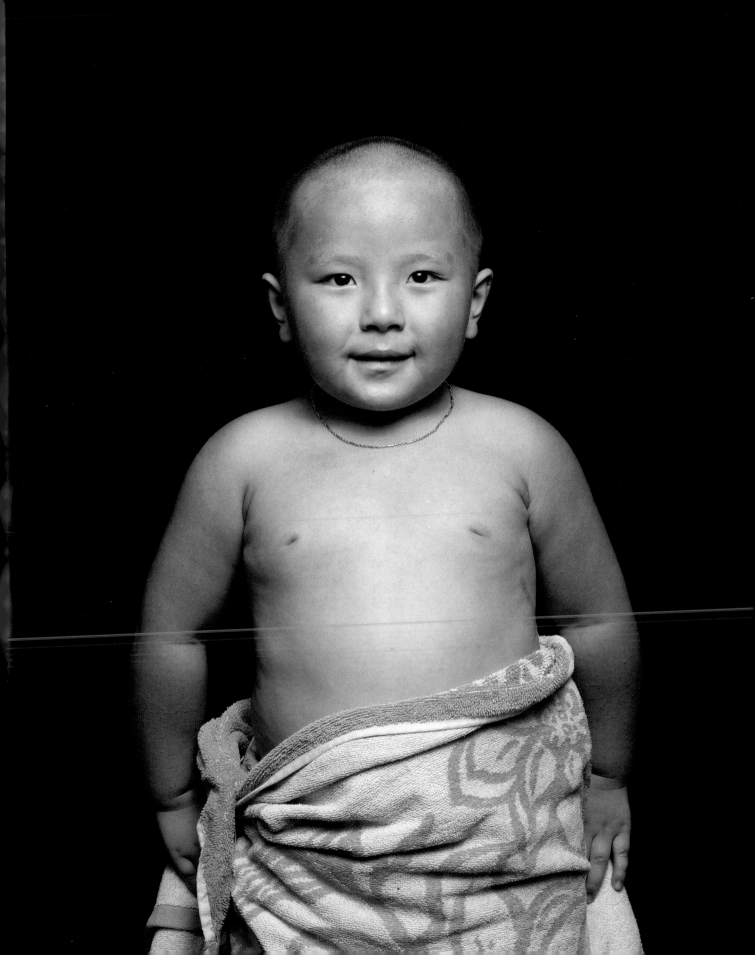

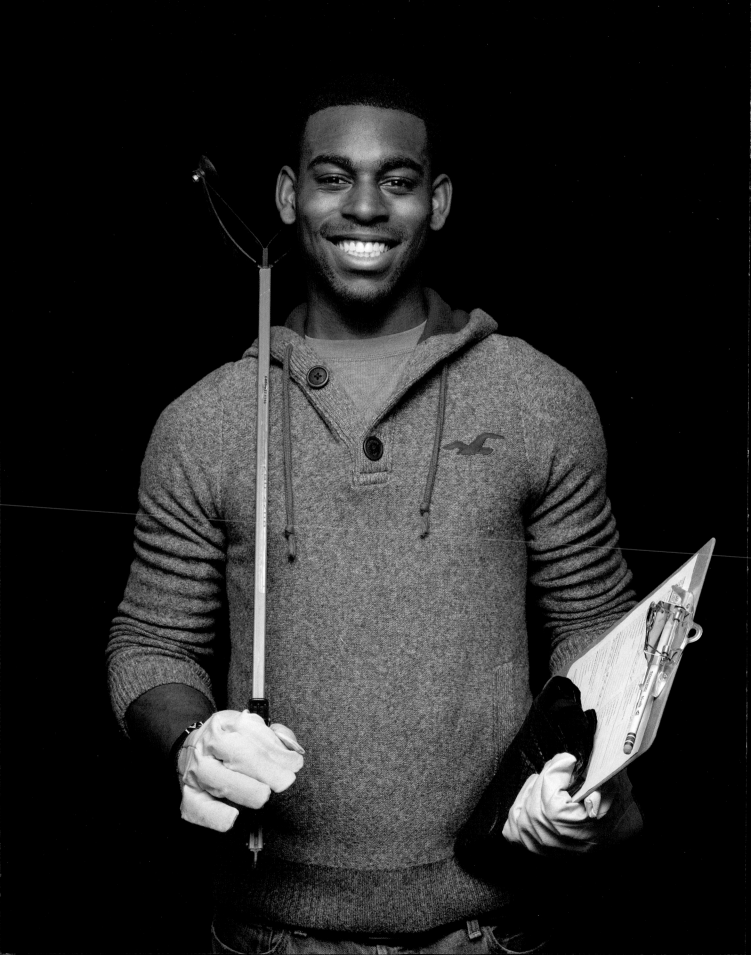

WATER LOCATIONS

The twenty-five water images throughout *Perimeter* are presented chronologically and represent each of my thirteen days of travel around the lake.

Milwaukee, Wisconsin
July 16, 2012, 8:51 a.m.
Pages xii–1

Kenosha, Wisconsin
July 16, 2012, 11:34 a.m.
Pages 6–7

Chicago, Illinois
July 17, 2012, 9:49 a.m.
Pages 12–13

Beverly Shores, Indiana
July 17, 2012, 5:19 p.m.
Pages 18–19

Michigan City, Indiana
July 17, 2012, 6:09 p.m.
Pages 24–25

Holland, Michigan
July 18, 2012, 3:10 p.m.
Pages 30–31

Whitehall, Michigan
July 19, 2012, 1:48 p.m.
Pages 36–37

Frankfort, Michigan
July 20, 2012, 6:03 p.m.
Pages 42–43

Northport, Michigan
July 21, 2012, 1:29 p.m.
Pages 48–49

Petoskey, Michigan
July 22, 2012, 6:22 p.m.
Pages 54–55

Middle Village, Michigan
July 23, 2012, 11:07 a.m.
Pages 60–61

Cross Village, Michigan
July 23, 2012, 12:16 p.m.
Pages 66–67

Brevort, Michigan
July 24, 2012, 9:30 a.m.
Pages 72–73

Stonington, Michigan
July 24, 2012, 5:24 p.m.
Pages 78–79

Ford River, Michigan
July 25, 2012, 10:12 a.m.
Pages 84–85

Arthur Bay, Michigan
July 25, 2012, 11:49 a.m.
Pages 90–91

Green Bay, Wisconsin
July 25, 2012, 4:36 p.m.
Pages 96–97

Namur, Wisconsin
July 26, 2012, 5:39 p.m.
Pages 102–103

Gardner, Wisconsin
July 26, 2012, 6:09 p.m.
Pages 108–109

Sturgeon Bay, Wisconsin
July 26, 2012, 6:31 p.m.
Pages 114–115

Ephraim, Wisconsin
July 27, 2012, 10:15 a.m.
Pages 120–121

Washington Island, Wisconsin
July 27, 2012, 4:56 p.m.
Pages 126–127

Sheboygan, Wisconsin
July 28, 2012, 3:10 p.m.
Pages 132–133

Port Washington, Wisconsin
July 28, 2012, 6:06 p.m.
Pages 138–139

Milwaukee, Wisconsin
July 28, 2012, 8:14 p.m.
Pages 144–145

INDEX